(Art = Life) + Food = Experimental Eating

Experimental Eating

black dog
publishing
london uk

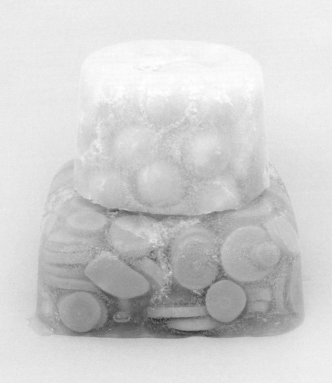

Experimental Eating is a diverse international survey of contemporary experimental food-based creative practice across art, design, science and socio-political community interaction from the mid-twentieth century onwards. The book is split thematically into four chapters, comprising profiles of over 60 individuals and groups working across this creative spectrum, pushing the boundaries of how we understand, experience and relate to food and the rituals of dining; their titles are meant to convey both literal and abstract notions of what lies therein. "Origins" features practitioners concerned both with the actual sourcing and growing of our food—from farming techniques through to the creation of lab-grown InVitro meat—and the socio-cultural themes that underlie its pre-production and global history. "Preparation" comprises variations on the actual making of meals and dishes, as well as accounts of how certain ingredients and foodstuffs are reappropriated in the hands of artists and designers with the intent of creating fresh cultural understandings and meanings in the process. In "Dinner", we see myriad interpretations of the meaning of eating as a base action, and how our understanding of this can be affected when carried out in specifically altered social and cultural contexts. Finally, "Leftovers" considers both how discarded foodstuffs can be used in a creative context, and the further implications within the contemporary proliferation of food waste generally.

The book's profiles are prefixed with a new introductory essay, "Eating Ahead — Art, Life & Food", by the Center For Genomic Gastronomy (Zack Denfeld, Cathrine Kramer and Emma Conley), which explores the work of practitioners featured and posits new starting points for observing the ever-changing status of contemporary food practice as a conduit for multidisciplinary expression and experience, whilst also giving insight into their own fascinating work, itself consistently straddling a line between wonderfully irreverent and cerebrally stimulating.

In addition, we have included a concise appendix of reprinted texts to supplement the original writing and visual profiles. Romy Golan's article "Anti Pasta" —first published in *Cabinet* no. 10 (Spring 2003) — delves in to the history of Marinetti's Futurists and their seminal *Futurist Cookbook*; an essential piece of exposition given the huge influence the group had on much of the work featured in *Experimental Eating*, though occupying a temporal context just a little too early to be profiled. Paul Lamarre and Melissa Wolf's "Preface" to *Food Sex Art—The Starving Artists' Cookbook* (itself and its accompanying video work are profiled within the "Preparation" chapter of the book) gives a concise potted history of the largely pre-war twentieth-century trends in art's appropriation of food practice, in this sense complimenting the Center for Genomic Gastronomy's introduction proper, itself bringing these trends bang up to date. Finally, we have included the French social anthropologist Claude Lévi-Strauss' classic essay on the semantic field of cookery, "The Culinary Triangle", which adheres detailed socio-cultural implications to a variety of cooking techniques.

Though the book is in no way meant to comprise a comprehensive academic thesis on this relatively nascent new spectrum of artistic and cultural practice, we hope that *Experimental Eating* will act as a primer to the uninitiated and an aesthetically pleasing document for the informed and interested.

⟵ Image courtesy Florent Tanet.

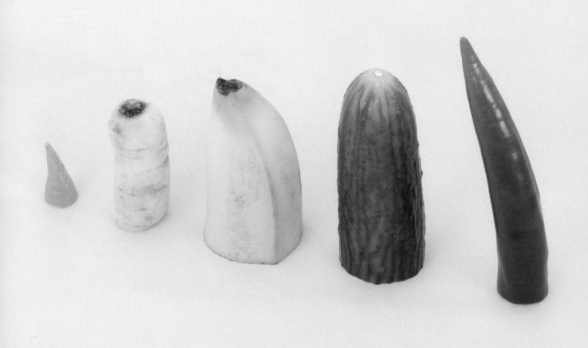

Eating Ahead
Art, Life & Food

———

The Center For Genomic Gastronomy
(Zack Denfeld, Cathrine Kramer & Emma Conley)

This book collects exemplary practices and experiments from the 1960s through to today that deal with gastronomy: the art of preparing and eating food. One definition of art is making the familiar strange. Nothing is more familiar than eating. Two to three times a day (if you are lucky), you pass a collection of animals, plants, other organisms and minerals (called 'food') through a hole in your face. Sometimes by yourself, more often in the company of others. This ritual takes place just about every single day of your life on planet Earth. What could be more familiar?

The artists featured in *Experimental Eating* insert themselves between the eater and the food in order to create a novel or unusual experience. During experimental eating the audience is thrown off balance, and needs to pay attention. Non-normative ingredients, experiences and etiquette are employed. Things taste, look, smell, feel and sound different to usual.

Experimental Eating is an opportunity to document the unusual food rituals humans repeatedly perform

half of this equation. Art about eating is nothing new, but this book generally focuses on a range of cultural practices that have only emerged in the last 50 years.

❶ (Art = Life) + Food = Experimental Eating

From sixteenth-century still lifes to Futurist cookbooks, food and art have a long and entangled history; but the work collected in this book generally begins in the 1960s for a reason. Many of the projects featured in *Experimental Eating*—and our own work as the Center for Genomic Gastronomy—take inspiration from the post-studio art practices that came to the fore in the 1960s and 1970s. Post-studio artists wanted to decrease the distance between art and life. Sometimes they wanted to make work that was immediate and not mediated; to work collectively, share their work outside of the museum and gallery system, and create experiences that took place in real-time or were ephemeral. Many post-studio approaches to art were more haptic than optic. They involved assembling people, artefacts and organisms in novel configurations.

> "Art is a sensory experience, and experimental eating adds layers of smell, taste and texture to the visual stimulation that still dominate contemporary art practice."

or to reimagine the entire act of eating. The practices in this book embrace other ways of consuming and destroy the assumption that there is a correct way to eat. The desires of the artists are as varied as the food they depict or serve, but because everyone seems to have an opinion about food, these practices tend to be more immediately accessible than many manifestations of contemporary art. Art is a sensory experience, and experimental eating adds layers of smell, taste and texture to the visual stimulation that still dominates contemporary art practice.

Some artists create art about gastronomy and the food system, while others use food as a Trojan horse in order to address related or even tangential topics. If you dig deep enough, food is about farming, biology, ecology and Earth science. However, with a focus on eating, most of the works in this book pick up at the farmers market or supermarket and end with digestion. Experimental eating primarily takes place in the kitchen, at the dining table and during a meal. Agriculture and gastronomy are inseparable, but experimental eating focuses primarily on the second

Artists such as Mierle Laderman Ukeles, Peter Fend and Agnes Denes (to take an arbitrary cross-section from New York) pushed art practice so far outside of the act of image creation, that it became unclear if what they did could even be called "art". A following generation of collectives like the Critical Art Ensemble, the Institute for Applied Autonomy, the Center for Land Use Interpretation and the Bureau of Inverse Technology experimented with organisational aesthetics and freely employed both technological mediation and performative immediacy as the circumstances required. In order to create their interdisciplinary artworks these groups identified specialist collaborators or acquired skills in non-art domains such as robotics, digital cartography or the life sciences. These collective practices from the 1990s to the 2000s moved fluidly between interactions on the street, exhibitions in the sanctioned art world and engagements with specialists in the halls of academia and research institutions.

⬅ ⬅ ➡ Courtesy Florent Tanet.

The Center for Genomic Gastronomy and many of our peers who research food have been drawn to the strategies of post-studio practice and artists' collectives. Preparing and serving food, or intervening in networks of food production and consumption, are logical starting points if your goal is to make art that takes place in real life and in real time. Experimental eating is an opportunity for the artist and their audience to get away from the glowing screens that increasingly dominate our lives. Food reconnects us with our immediate surroundings and creates a frame for real-time interaction uninterrupted by needy digital devices. Ingredients are derived from living organisms and make visible the flow of biomass through our contemporary economic system. Ingredients rot and release aromatics when they are heated. They call attention to themselves through multiple human senses. Artists can transform raw ingredients into artistic works, but food doesn't stick around long enough to be easily collected by museums. The flavours and smells of food are a direct and immediate language for artists to communicate with, but the required labour and cost of ingredients needed to create novel food experiences guarantees that the audience for live experimental eating will be small but sensually engaged, and the production will be a collective effort. Experimental eating is rarely the act of a lone genius. Images or representations of food (part of the experimental eating canon) have a slightly longer shelf life, and can be reproduced and recuperated with more ease, but the experience of an audience-who-eats is bound by time and place.

This book maps out some of the lineages of post-studio art involving food production, a variant arguably instigated by Gordon Matta-Clark in 1971. FOOD, a conceptual, but functioning restaurant, managed and staffed by artists sat somewhere between a small business and artist hang out. FOOD produced performances, ephemera and more often than not, food that could actually be purchased and eaten, and it set the stage for a range of practices in this book that sit provocatively between conceptual performance art and commerce. Some projects are one-off meals, while others are ongoing supper clubs, pop-up restaurants and even long-established food carts that serve food to regular customers. Such initiatives are not profit-making but they do demonstrate the ability of artists to wear the camouflage of everyday life and exist within an economy of food service, even if temporarily. Now we move from unsuspecting audiences to unexpected guests.

❷ **Documenting & Explanatory Models**

At the other end of the spectrum from art that seeks to exist in real time and real life are artists who use the documentary and archival potential of art to tell stories or examine systems. These food stories may fall between the cracks of journalism and history, or are best told using combinations of image, object and text. Some artists document aspects of the food system in order to establish a new point of a view or to trace a journey, helping the viewer witness and understand the human food system as it really is. Artworks in the documentary mode in this book include Lonnie van Brummelen and Siebren den Haan's *Monument of Sugar*, 2007, and Gerco de Ruijter's *Crops*, 2012. These artists take advantage of forms such as filmmaking, image collections and digital archives in order to create databases that can be added to over time or reinstantiated depending on the exhibition context or means of dissemination. These works often have a didactic or diagrammatic purpose, but in other cases the voice is more personal and subjective.

The real question is: do you really want to know how your sausage is made? Whereas industrial food producers and the majority of restaurants work hard to hide the process of food production from the eater, experimental eating is an opportunity to document the journey and preparation process of food. Although the act of eating is familiar to every human, eaters across the planet are increasingly alienated from the production of food.

The Mutato Project, 2006, is a photographic collection and online archive of raw fruits and vegetables that documents the botanical anomalies in shape, size and colour that cause individual plants to be excluded from supermarkets. These are the most humble of ingredients. They only look fantastical because most eaters are accustomed to being confronted with standardised and curated fruits and vegetables that reach the market from the field. Europe and America both engage in a gastronomical culling: either a bureaucrat decides what botanical deformities are unacceptable or someone in marketing does. Either way, perfectly edible and nutritious fruits that don't conform to those standards are thrown away, or sent to second tier outlets. *The Mutato Project* archives these outcasts, and lets us in on an unseen side of food production.

At the Center for Genomic Gastronomy we have recently been documenting the history of mutation breeding, in particular radiation breeding—the process of exposing plants and seeds to chemicals or radiation

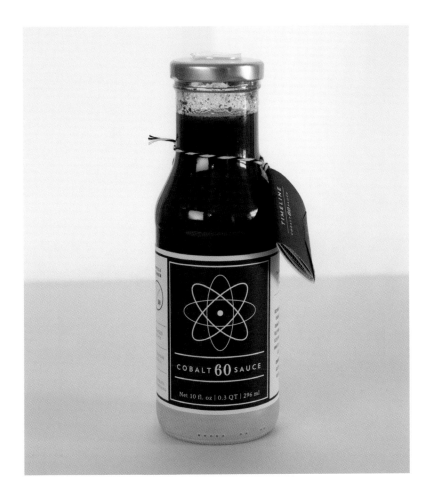

⊕ *Cobalt-60 Sauce*, 2013. Courtesy the Center for Genomic Gastronomy.

in order to cause random mutations. Mutation breeding is an agricultural technology that has proliferated globally since the end of the Second World War. For over 60 years, scientists on six continents have been exposing plants and seeds to radiation and chemicals in order to induce mutations. Like many newly developed technologies, especially those promulgated directly after the Second World War, mutation breeding was touted as a technological solution to complex social problems such as global hunger.

Our *Cobalt-60 Sauce*, 2013, is one instantiation of this research: a barbecue sauce made from mutation-bred ingredients featuring radiation-bred ingredients such as: Rio Red Grapefruit, Milns Golden Promise Barley and Todd's Mitcham Peppermint. In order to create the sauce we had to identify, source and assemble commercially available mutation-bred plants. More than 2,500 mutant crop varieties have been registered with the United Nations and the International Atomic Energy Agency, but they are not labelled on store shelves, and identifying the provenance of mutation-bred varieties requires reading primary source documents, news articles and even historical advertising copy. These curious cultivars populate our human food systems and sit anonymously on our supermarket shelves.

When served publicly, the *Cobalt-60 Sauce* creates a frame for asking questions about the mutation-bred ingredients that are being served, and for elaborating on the similarities and differences between the history of mutation-bred crops and contemporary controversies surrounding genetically modified crops. 60 years

after the launch of mutation breeding programmes around the world, the initial hype surrounding the technology has worn off, and fears about possible human and environmental health consequences have similarly diminished. *Cobalt-60 Sauce* is a project in the documentary mode that seeks to highlight a forgotten history and connect it to the controversies and debates of today.

❸ Inviting Others

Eating often takes place during an event called a "meal". A meal is an organised practice that draws on a body of rituals and tools, has a pre-planned menu and a set number of invited eaters. Meals usually involve friends, family members or people who are connected through kinship networks. Only rarely do we dine with complete strangers. It would be peculiar for you to show up at a family picnic in a public park and expect to be fed if you had never met the other diners—it is annoying to picnickers when ants crawl on their blankets or bees land on their food. But meals are permeable things and uninvited human and non-human guests do show up from time to time.

Experimental eating expands on the everyday guest list. Animals, microorganisms, and human guests from opposing sides of a political conflict don't usually sit down to dine together, but the meals in this book take into account the excluded, or intentionally invite the Other.

Hosting a meal can be a tricky negotiation process. Some guests may begin conversations that are uncomfortable for the other eaters. A good host doesn't want to enable unnecessary conflict, but experimental eaters may very well be interested in debating taboo topics while dining. Food is a starting point for conversation. Breaking bread can break the ice.

For example, Jon Rubin's *Conflict Kitchen*, 2010, "serves cuisine from countries with which the United States is in conflict" and complements meals with events and performances that spark conversations not had in public, much less in the polite dining rooms of the United States of America. *Trespass the Salt*, 2011, by Larissa Sansour and Youmna Chlala unites the neighbouring countries of Palestine and Lebanon by hosting a meal between the two locations, in virtual space. The viewer of this video installation witnesses the dinner between guests on either side of political boundary. Even being exposed to the cuisine

and eating habits of the Other is a starting point for establishing familiarity, humanity and for asking new kinds of questions.

It is slightly more difficult to keep out unwanted non-human guests than human diners. Ants, flies, mould and fungus just don't take no for an answer. We usually cope by attempting to not picture them while we are eating. We don't conjure up images of pigs while consuming bacon, nor envision the life cycle *Penicillium roqueforti* when eating blue cheese. Whenever we make images in our heads or in the world, we leave some things out. Images of meals are necessarily constrained. Not every organism or ingredient is accounted for. For example, it is difficult for humans to see and acknowledge the massive number of the microorganisms that predigest their food or the microorganisms that live on and in their body. The numbers are too large, and the organisms are too small.

And although we love to eat fermented food, we tend not to identify by name the bacteria or yeasts that make the food desirable. It's not generally considered good manners to remind everyone that the act of human eating inevitably involves the death of non-humans. Klaus Pichler's *One Third*, 2011–2012, is a series of carefully staged photographs of rotting foodstuffs that make us wretch whenever we see them. Images of decomposing food are a reminder that our food consists of and is inhabited by organisms; images and sculptures of decomposing food whisper "It is inevitable that your food will die. (And you will too.)"

What about non-human diners that are closer to our size? Some families feed their pets at the same time as they themselves eat, but mostly the non-humans that exist in our environment are not invited to dinner. In order to correct this omission, in 2011 the Kultivator collective from Sweden created a meal that could be eaten by both humans and cows simultaneously. Natalie Jeremijenko's *Cross Species Adventures Club* is an ongoing event which includes dishes that are nutritious, tasty and beneficial for both human diners, insects, fish and other organisms. Marina Zurkow's 2012 happening *Not an Artichoke, Nor from Jerusalem* was a dinner where native and invasive species are harvested and served. These experimental meals ask us to consider who and what belongs, extending our ability to envision what is difficult to see, or to invite difficult guests.

Finally there are the uninvited guests of contaminants and pollutants that exist in our food and in the environment around us. Air, water and soil pollution enter our foods and our bodies,

⬅ ➡ ➤ *Smog Tasting*, 2011. Courtesy the Center for Genomic Gastronomy.

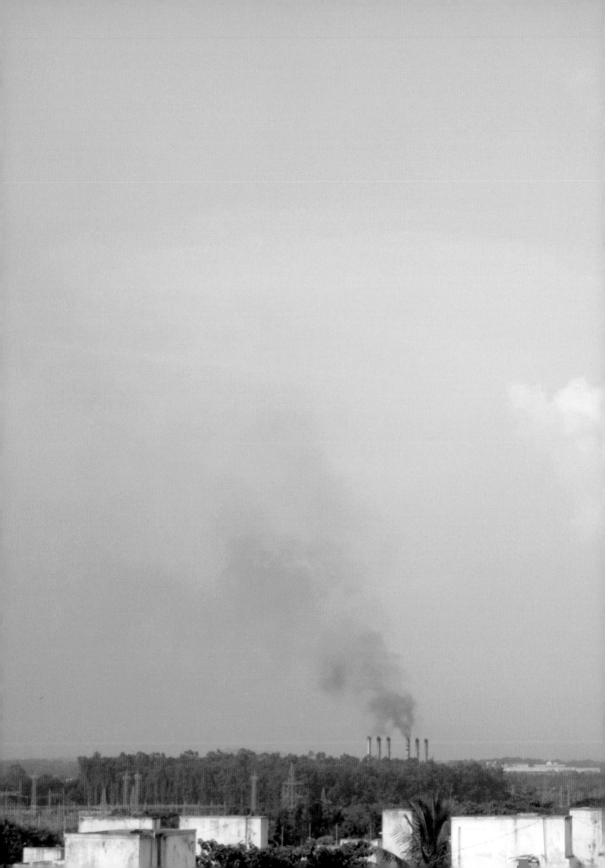

often shaping the flavour and nutrition of the food we consume. The Center for Genomic Gastronomy's *Smog Tasting*, 2011, is a research project that makes the invisible ingredient of smog both visible and tastable; the research takes the form of egg-whipping performances and the production of recipes. During the performances, egg whites are whipped in various outdoor environments in order to harvest air pollution. Whipping eggs creates egg foams, which are up to 90 per cent air. Particulate matter and other airborne pollutants get trapped in the batter. Smog from different locations can be served, tasted and compared in the form of polluted meringues.

Smog Tasting has also been served in less polluted geographies, where a more metaphoric approach has been taken. Quantitative air pollution data from the local site and from cities around the world are translated into a collection of recipes with simulated pollutants, so that participants can taste differences in air quality. Quantitative data is most often visualised or sonified, but the *Smog Tasting* creates an opportunity to use smell and taste to interact with data.

From a culinary perspective, environmental pollutants are unwanted ingredients in the human diet. Taking into account the presence, flavour and nutritional impact of these invisible ingredients is one method of experimental eating. Making meringues at traffic intersections and on rooftops looks unusual and tends to draw a crowd. Conducting the *Smog Tasting* in public is a frame for asking questions about the relationship between food, the environment and our body, and seeking answers collectively.

❹ Site and Spectacle

Where should we eat? What should it feel like? What if getting food into your mouth required the assistance and co-operation of your fellow diners? The following projects experiment with the where and how of eating. Marije Vogelzang's *Sharing Dinner*, 2005, ties strangers to a tablecloth, their every move shifting the configuration of the table. Each diner is required to share ingredients in order to complete a dish, and must engage in a complex dance of collaboration and consumption.

The same food tastes very different if it is eaten al fresco, on a tree-lined avenue or underground, in a former missile silo. Our attention and senses are modulated based on the architecture or environment we find ourselves in. Environmental aspects such as light, air quality and temperature set the mood. Putting eaters in a novel setting or constraining their movements ensures that they will be in the moment and paying attention in a way they would not in their own home or a familiar restaurant.

The temporary Ridley's pop-up restaurant, devised by the Decorators and Atelier ChanChan in 2011, not only raised diners well off the ground, in an unusual urban location, but also replaced the dumbwaiter with an entire dining table that could be raised and lowered between floors. Throughout the dinner the architecture of the meal was reconfigured, and the flow of conversation and consumption was disrupted.

Between the act of entering an architectural space and food finally reaching your stomach there are a set of tools, garments and utensils required to perform the act of eating. Soup spoon, gravy boat, oyster knife, spork. Bib, napkin, deep fryer, drinking straw. Artists who disrupt the tools of the meal, disrupt the patterns of our body in space and time.

SWAMP's *Meat Helmet* is a tool that forces the eater to overstay their welcome. After typing in the number calories contained in your McDonald's Big Mac (560), the *Meat Helmet* forces the eater to continue chewing until they have burned off all of the calories they just consumed. Watching a diner with a cybernetic eating-helmet for eight hours in a McDonald's causes a counter spectacle to the colourful advertising and interiors of the McDonald's chain. SWAMP has conducted other studies of work atmospheres and material production by living and eating in a single WalMart for 24 hours and by continuously looping around a McDonald's drive through, buying and consuming a single item at a time.

As part of our research into mutation breeding the Center for Genomic Gastronomy has experimented with vortex cannons as a means of delivering clouds of mutation-bred peppermint oil. Most eaters have fun releasing puffs of atomised liquid into the air, but are slightly more hesitant when they learn about the history of the ingredient they are letting float around the room and into their mouths. The spectacle of humans making small green mushroom clouds and licking the air is just one created by modifying the tools, spaces and architectures of eating.

❺ Decadence For All

Experimental eating has an uneasy relationship with abundance, excess and inclusiveness; it often feels more like a celebration or a special occasion, rather than something one would do everyday. Some artists riff on the potential for spectacle and decadence inherent in banquets while others decontextualise ingredients that are mundane or humble in order to consider them in a new way.

Displaying large quantities of expensive food is still one of the ways that societal elites communicate their wealth or power. Exotic ingredients and flavours

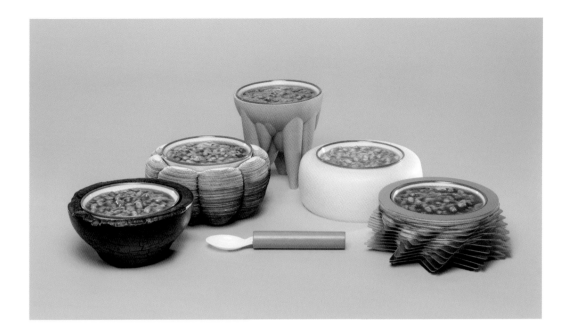

⬆ *Heinz Beanz Flavour Experience*. Photography: Nathan Pask. Courtesy Bompas & Parr.

indicate that an elite has the access, knowledge and the wealth to acquire ingredients from far off places, and compose them into something that is satisfying to eat. Sometimes just sheer quantity is enough to show off. Jennifer Rubell's *Icons*, 2010, draws on art historical references to put on a banquet in a gallery. Piles of meat, vegetables and junk food, champagne fountains and spigots of alcoholic beverages are installed throughout the museum; this is the decadence of a post-sixteenth-century still life painting that has jumped off the canvas so it can actually be consumed.

Should truly decadent experiences only remain within reach of the privileged few? Is universal access to hedonism and pleasure a goal worth fighting for? Industrialisation and Fordism paved the way for optimisation and standardisation, strategies that have significant consequences when applied to food systems at a planetary scale. Can experimental eating prototype universal access to pleasure through food?

Bompas and Parr have an oblique take on decadence and abundance. They have employed the garish colours and the lovely wobble of jelly (Jell-O to Americans) to create spectacular sculptures. Their work often utilises food products that are highly processed, commercially branded and vilified by foodies. For the *Heinz Beanz Flavour Experience* they matched five flavours of baked beans with handmade bowls and audio-emitting spoons. Their work builds on the detached celebration of industrial food culture typified by Andy Warhol and his famous quote, "A Coke is a Coke and no amount of money can get you a better Coke than the one the bum on the corner is drinking. All the Cokes are the same and all the Cokes are good."

Taking a much more critical approach to industrial food culture, Paul McCarthy has employed bottles of ketchup and chocolate syrup as stand-ins for bodily fluids in much of his work. The recontextualisation of these ubiquitous condiments transforms the everyday into the grotesque, and creates images that have the power to disturb.

Moving away from the packaged uniformity of industrial food, Carl DiSalvo's collaborative work is explicitly process-based and engages in the hands on co-creation of food with an audience. Projects such as *GrowBot Garden*, *Food Data Hacks* and *Kitchen Lab* combine food, technology and community in order to generate locally specific cultural expression and instigate social action. These projects have attempted to create space for co-creation between amateurs and experts with various domain expertise. An organic farmer

drawing on their own experience in the field likely has very different insights about the potential use for agricultural robots compared to an electrical engineer.

Finally, our own *Vegan Ortolan*, 2012, is an on going cooking contest to make the best vegan simulation of the cruellest meat dish ever invented: the Ortolan. The sheer number of ingredients and skills needed to simulate the bones, organs and flesh of a small bird is enormous. Making this simulation a truly delicious experience is even more difficult. This project appears to be a form of culinary absurdism, but the process is also a form of cultural exorcism that allows the novel culinary culture of veganism to replace animal cruelty with culinary complexity and abundance.

❻ **Three Modes of Speculative Gastronomy**
In order to succeed, novel food movements need to be beautiful, delicious and open to experimentation, and one branch of experimental eating that this book explores is speculative gastronomy, which employs the tools, symbols and processes of food preparation in order to imagine food futures, prototype alternative cuisines or critique existing culinary practices.

Part of our role at the Center for Genomic Gastronomy is conducting workshops that train creative practitioners, food professionals and amateurs to imagine and test a range of food futures. Sometimes this involves the creation and dissemination of images and mock-ups. Other times prototyping the future demands the procurement of edible organisms and chemicals.

There are at least three approaches to asking "What if?" in relation to food: diegetic, figurative and realist. Diegetic speculative gastronomy involves the creation of props and images of food. Figurative speculative gastronomy consists of metaphors that you can eat. Realist speculative gastronomy is the thing itself, not metaphors; foods from the future that can be served to human eaters, today.

Speculative gastronomy practice exists all along this continuum, but it may be useful to use these three approaches as points on the map, and to draw on examples from this book relating to InVitro meat to illustrate each approach. InVitro meat—animal cells grown in a lab for the purpose of human consumption—is interesting because it is a cutting edge technology that has been dreamed about for decades, but was realised and presented in public by artists as well as scientists. Since the serving of the first lab-grown meat by the Tissue Culture and Art Project, artists have continued to envision, critique and debate InVitro meat.

An example of diegetic speculative gastronomy is *Dressing the Meat of Tomorrow* by James King, 2006: a project that imagines one way InVitro meat might look, taste and be served if, or when, it leaves the lab research phase and is put into commercial production. The piece is exhibited as a plastisol sculpture and a short text, through which the viewer is provided with minimal context about the technology of InVitro meat. The diegetic prototype is a prop constructed to complete a fictional story that the audience can view and discuss, omitting any of the actual biological materials involved in InVitro meat production.

A photograph of the sculpture and text related to the piece has been remediated in various forms on the Internet—the iconic imagery and fantastical narratives make this kind of work ideal for dissemination and debate on such a medium—and continue the conversation and debate beyond the confines of the gallery where the piece was exhibited.

The diegetic approach allows the artist to express something about food, or the future, without being constrained by material reality, the laws of physics or biology. By creating artefacts and fictions that present a plausible and well-articulated future reality, audience members can imagine themselves inhabiting a fiction, casting themselves as an actor and thinking through the implications. However the audience is not given access to or allowed to eat diegetic prototypes—food which is unsafe, inedible or can only be simulated, as it simply doesn't exist in biological/material form.

One historical example of diegetic speculative gastronomy is the pill food that featured in fiction and film throughout the twentieth century: abstract little pills promised everything from the flavour experience of an entire five-course meal to your complete nutritional needs for an entire week. Although no one has ever successfully created or sold pill food that delivers on those imagined possibilities, we now live in a world of ready meals, meal replacements and molecular gastronomy. Pill foods were used as props in films to express excitement about scientific advancement or horror at the alienation inherent in technological progress—different viewers might interpret these food props in either way depending on their own assumptions. But the image of the pill food, the context it was pictured in and the performance of a human actor consuming it all helped build the vision and prompt viewers to think through the implications of technological advancement.

———

↩ Courtesy Florent Tanet.

Figurative speculative gastronomy involves the creation of food that can be consumed by humans, though it need not taste good or be nutritious. In the figurative mode audience members move from viewers to active participants. They are pushed beyond commenting on a future scenario in the abstract, and are confronted with the reality of consuming and incorporating into their body something unusual or uncomfortable.

While it shares many qualities with diegetic work, in figurative speculative gastronomy more emphasis is placed on the experiential, haptic and edible aspects of the fiction that is being conjured up. Figurative creations can combine images, media, sculpture and performance, but what sets them apart is their use of food that can be consumed.

ArtMeatFlesh is a series of performances by Oron Catts and the Center for Genomic Gastronomy that have taken place in three countries since 2012. During these live cooking events, two teams composed of artists,

of producing and serving actual insect sausages — via their ongoing work on InVitro meat. In order to create and serve their project *Disembodied Cuisine*, 2000–2001, the artists spent many years working in life science labs to acquire the skills needed to conduct tissue engineering and create a piece of disembodied animal tissue that could be served as food. In order to serve this novel food, the artists had to go beyond exploring the ethical, legal and cultural constraints of InVitro meat; they had to fill out the paperwork and conduct due diligence as well as provide a conceptual and physical context for the meal to take place in a safe and legal fashion.

The realistic approach to speculative gastronomy prides itself on generating material instantiations that go beyond metaphors. By seeking out novel ingredients, biotechnologies and cooking processes, and by serving them to an audience, realism implicates the eater directly in the imagined alternative food culture. These experiences remain experiments and are not necessarily

"Mainstream media outlets cover celebrity chefs and food culture like never before and there has been a massive growth in specialised media covering every aspect of food culture."

scientists, philosophers and chefs compete in a kitchen where they create dishes for a live studio audience to taste and judge. Each dish addresses one aspect of InVitro meat or the future of protein production and consumption. Although no actual InVitro meat has been served at *ArtMeatFlesh* events, the ingredients used have included products such as fetal bovine serum (FBS) and horse serum, which are used in the lab during the creation of InVitro meat. Members of the audience have to decide whether they feel comfortable eating these ingredients after learning about their ethical, ecological and health consequences. Often people who initially feel willing (or not) to eat something change their mind when they are able to experience the sight, smell and sound of the food before tasting it.

In a similar vein, discussions about converting to an insect diet are very different when an audience is shown seductive images of imagined insect sausages or when they are actually presented with real cooked grasshoppers or ants.

❼ **Realism in Speculative Gastronomy**
The Tissue Culture and Arts Project also presents an example of realism in speculative gastronomy — like that

repeated, or may not scale well for commercial or even artistic purposes, but can open up new pathways for receiving direct feedback from eaters.

Many artists oscillate back and forth between these modes depending on the circumstances and the questions they are interested in. For example, artist John O'Shea explores our relationship to animals and the ethics of meat consumption across all three modes. His ongoing project the *Meat License Proposal* aims to a pass a law in Great Britain requiring every meat eater to slaughter an animal at least once, and the artwork documents his investigation into the legal process of proposing such a law. The project is diegetic speculation, but grounded in a concrete understanding and exploration of the legal framework of the UK. His *Black Market Pudding* project proposes an ethically conscious food product (black pudding made with blood from a living pig), which has been served and eaten, but not yet bought and sold commercially.

Similarly, Sissel Tolaas and Christina Agapakis' *Self Made*, 2013, sits between modes of speculative gastronomy. The artists created cheeses with starter cultures isolated from the hands, feet, noses and armpits of artists, scientists and cheesemakers.

However, they do not publicly serve the cheese as food. This work seems to exist between the world of diegetic prop making and the creation of a novel foodstuff that can be served to participants who are willing to eat it. Each of the three modes of speculative gastronomy are excellent tools for asking questions, but each comes with its own affordances and limitations.

⑧ Eating Ahead: Towards A Critical Approach to Experimental Eating

Something big is happening in the world of food, across the entire planet, and we need the voices of artists, outsiders and experimental eaters to make sure that we collectively build a food system that is more just, beautiful and biodiverse than the one we currently have.

Experimental Eating is an essential collection because seemingly everyone is interested in the topic of food. Mainstream media outlets cover celebrity chefs and food culture like never before and there has been a massive growth in specialised media covering every aspect of food culture. It is cool to cook. On the other hand, academics and policymakers fret over the ecological and economic implications of our ever-growing human food systems. There are more mouths to feed, increasing inequality and the same amount of land. Will we be able to feed everyone? How do we move away from non-renewable resources as they become scarce? Resource constraints and food insecurity are being examined from both and agricultural and a culinary angle. Finally, trend forecasters, social engineers and venture capitalists are looking all over for inspiration to create new products, increase profits and cause creative disruption.

Since the establishment of the Center for Genomic Gastronomy in 2010 we have been sharing many of the projects and practices contained in this book with students, collaborators and colleagues. One way we plan to use the *Experimental Eating* book in our own practice, is as a conversation starter with people who think deeply about food cultures and food systems, but not necessarily about art. Even audiences that are sceptical about the purpose or significance of contemporary art pay attention when food is involved. Whether these audiences recognise it or not, contemporary art is an essential domain of experimentation and research because art still makes room for unpopular views, freedom of expression and non-instrumental research. Few other disciplines can compete on these aspects. Discussions around the current global food system are obsessed with increasing yield and efficiency, often ignoring biodiversity and resilience. As humankind goes about reinventing the global food systems, it is important to consider the beauty, complexity or criticality in these projects and how that could translate into non-art domains. These projects are a good starting point for everyone who wants to experiment with eating.

Origins

I

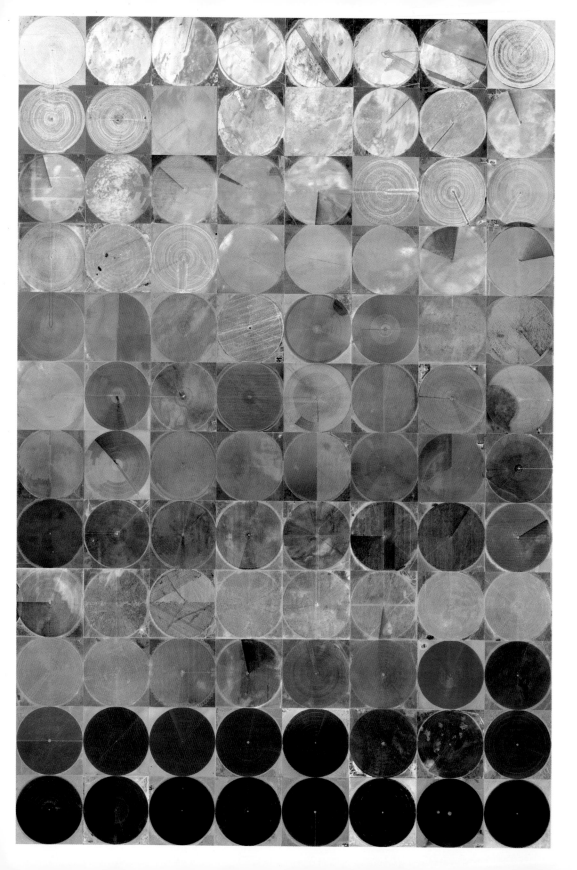

Gerco
de Ruijter

The Rotterdam-based photo-artist Gerco de Ruijter was born in Vianen, The Netherlands. His landscape photography is typified by its lofty bird's-eye view style —attained via various devices, including "an elongated fishing rod, which he customised with a timer, and a kite, which he operated by transmitter"—rendering his chosen landscapes as abstract expanses of meditative texture and colour.

The artist's 2012 work *CROPS*—first exhibited at Washington DC's Hirshhorn Museum and Sculpture Garden's Black Box space in 2013—shares this perspective, though skews the source material slightly by appropriating existing images of spherical irrigation plots—created by a mechanical arm rotating around a fixed, central base—in the American southwest from Google Earth. Over 1,000 images were formatted to fit a standardised geometric template by the artist, who then sequenced them into a stop-motion animation, creating a visual effect sitting simultaneously between watching a vinyl record spin at hyper speed, "the jittery motion of *Steamboat Willie*-era cartoons",[1] and the intensely kinetic 16mm film work of Paul Clipson. The result is a breathtaking, borderline hypnotic, three minute rush of fluttering visual information, with the machinery—unrecognisable from the viewpoint—repositioned as a clockwise moving 'hand'. This becomes the only aesthetic constant within the 'film'—asides from the rigid geometric consistency of the plots—the visually grainy intricacies of the crops themselves shifting wildly throughout and affording a beautiful, painterly aura to the piece, appropriate given de Ruijter's belief that "What is similar in my work and that of abstract geometrical painters is foremost that we do not dish up a story or a deeper meaning. The viewer sees nothing but the image itself."

1 http://www.washingtoncitypaper.com/articles/44690/black-box-gerco-de-ruijter-at-hirshhorn-reviewed-irrigation-surprisingly/.
Cropped / Contact Sheet #3 (colorscheme), 2012, Ultrachrome print 16"x 24", edition of 30. Courtesy the artist.

Erwin Wurm

Based in Vienna, Austrian artist Erwin Wurm is best known for his humorous take on conventional formalism in sculpture. A concern for mass and volume lends itself to the bodily shapes and swells of anthropomorphised objects such as in *Fat Convertible*, 2004. Framing the body as sculpture, physical mass takes on a more uncomfortable dimension. In *Self-Portrait as Cucumbers*, 2008, it is a favourite national food that becomes a suggestive and slightly obscene self-portrait, one that exposes a stereotypical male self-image to ridicule. Placed upon individual pedestals, the 27 carefully cast and painted acrylic cucumbers are clearly identifiable as vegetal, yet are simultaneously analogous to a man. This question of identity is further complicated by the singularity of the title and the number of represented objects. Made plural, the individuality of each pickle is more apparent: the varying heights, widths and curvatures comparable. With characteristic wit, Wurm undermines both the concept of a singular identity and formal Realism's attempts at accurate representation. Provoking a reaction somewhere between a grin and a grimace, Wurm manages to deliver a social commentary on the human condition via a playfully simple reconfiguration of the body's relationship with food and a common vegetable joke.

This absurdist interrogation of the relationship between the body, objects and consumption within the formation of identity plays through much of Wurm's sculpture, mixing sarcasm with something altogether darker. His *One-Minute Sculptures*, created throughout the 1990s, made collaborating participants into sculptures, forming ridiculous poses with a selection of everyday objects. Wurm's videos of the lead up to these sculptures amusingly documents their preparation, a process that lasts much longer than the eventual product. The temporary quality of the work is conditioned by the discomfort of the pose and often simply by a fight against gravity. Photographing this moment, Wurm's lasting impressions are less amusing, appear less spontaneous and playful, and become troubling voyeuristic images of the body as a transient object.

→ *Self-Portrait as Cucumbers* (detail), 2008, acrylic and paint, dimensions variable. Photography: Gallery Tomio Koyama. Courtesy Gallery Tomio Koyama, Tokyo, Japan, and the artist. → → *Self-Portrait as Cucumbers*, installation view at the Gallery Tomio Koyama, Tokyo, Japan, 2008, acrylic and paint, dimensions variable. Photography: Gallery Tomio Koyama. Courtesy Gallery Tomio Koyama, Tokyo, Japan, and the artist.

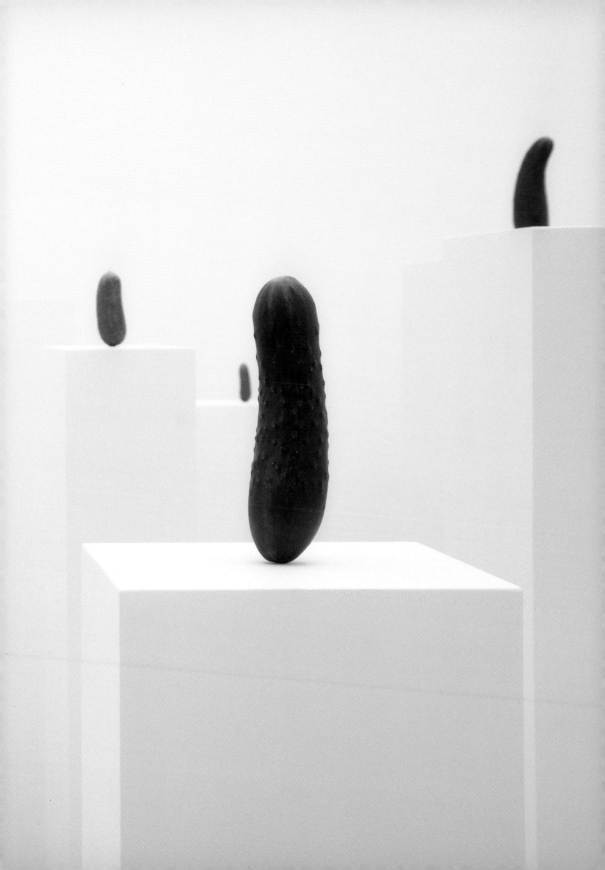

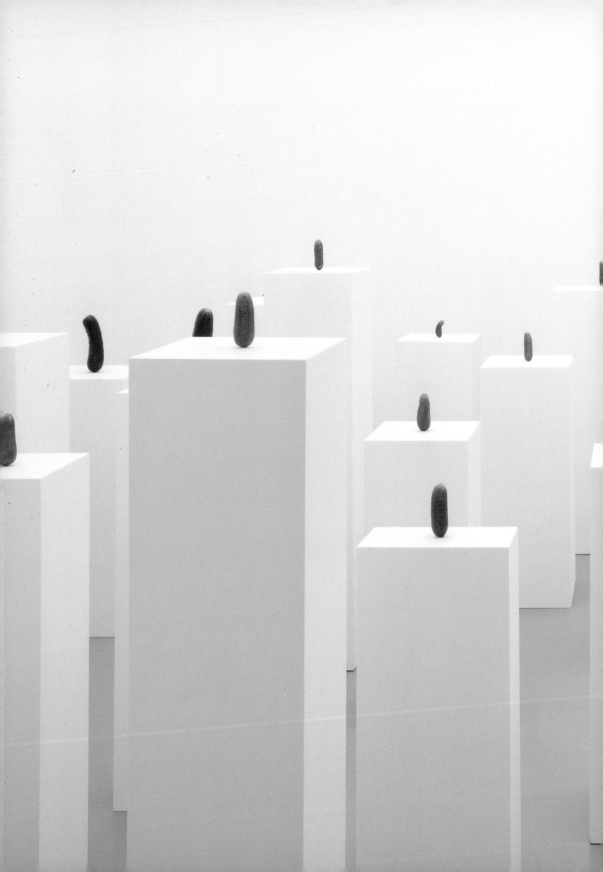

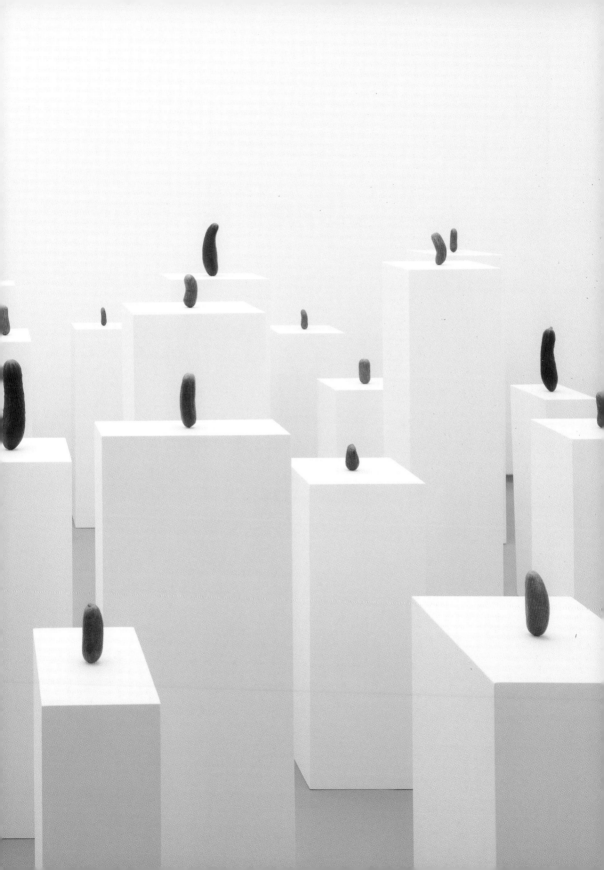

Larissa Sansour

Born in Jerusalem and educated in Copenhagen, London and New York, Larissa Sansour is a multidisciplinary artist whose work is concerned with contemporary political dialogues.

Falafel Road, Sansour's 2010 collaboration with the Israeli visual artist Oreet Ashery—in association with the Live Art Development Agency and Artsadmin—was based around the accusation that falafel was stolen from the Palestinians by Israel: a seemingly irreverent question but one which acts as a precursor to "an investigation into the intentional and systematic hijacking and eradication of Palestinian cultural history by the state of Israel".[1] Falafel has become a contested national symbol in the Near East, posited as a foodstuff nationalised into Israeli culture and used as an innate symbol of 'Israeliness' as part of the nation-building initiative in the second half of the twentieth century.

The project took the form of a month-long residency around various London eateries, supermarkets and market stalls, in which 20 communal meals of falafel were filmed by different artists—an idea inspired by Gordon Matta-Clark's FOOD project in the 1970s. The resulting interactions, the majority of which involve debates on questions of Palestine and Zionism, were edited and screened at the end of the project. The subsequent work thus takes the form of an abstracted psycho-geographical exilic map both of falafel outlets in London and of those attending the meals; a mix of the general public and guests specially invited by Sansour and Ashery.

Trespass the Salt, 2011, embraces a more hypothetical take on themes of border crossing and multinational socio-cultural integration, this time between Palestine and Lebanon. A three-channel video installation—created in collaboration with the Lebanese-American artist Youmna Chlala in 2011—depicts an intimate, fictitious feast; an imagined space in which the artists examine the cultural and political relationships between their two countries and the West.

1 http://www.larissasansour.com/falafel.html. ← Youmna Chlala and Larissa Sansour, *Trespass the Salt*, 2011, 3-channel video, 11'. Courtesy the artists. ↑ Oreet Ashery and Larissa Sansour, *Falafel Road*, 2010, video/web. Courtesy the artists.

Van Brummelen
& De Haan

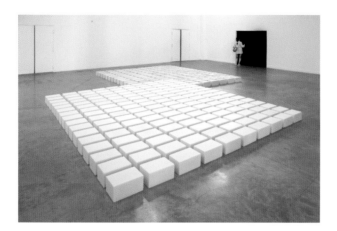

The Dutch duo Lonnie van Brummelen and Siebren de Haan both trained as art and philosophy students before initiating their collaborative artistic practice in 2002. Much of their multidisciplinary work—which includes film, sculptures and other mediums—deals with political and cultural issues, exploring these ideas via irreverent or conceptually abstracted avenues.

One such example is their 2007 project, *Monument of Sugar*, a collection of 304 identical sugar blocks arranged in a simplistic geometric pattern on a museum floor. The tangible work appears starkly minimalist; however, the thought process and philosophy behind the piece explores cerebral socio-cultural themes, spanning two continents in an ideological discussion on foreign trade. On learning that the price of European sugar was cheaper outside of the European Union, the artists travelled to Nigeria—one of the largest importers of the product—where they attempted to "reverse the flow of the subsidised commodity by purchasing Europe's sugar in Nigeria and shipping it back home".[1] In order to accomplish

this task, van Brummelen and de Haan were able to use a legal loophole to get around the European barrier on sugar—namely Harmonization Code 9703, which "ensures the duty-free passage of 'all monuments and original artworks, irrespective of the material in which they were produced'". The final 304 blocks which comprised *Monument of Sugar* are divided into two groups: one made in Europe and one in Nigeria. Each group was laboriously created from €1,000 worth of sugar, the process of which was documented in a 67-minute, 16mm silent film, shown alongside the blocks in the exhibit. The film, a mix of images and text, slowly tells the story of the project, paralleling the long and painstaking process of creating the artwork itself.

1 http://www.worldofmatter.net/introduction-monument-sugar-how-use-artistic-means-elude-trade-barriers#path=rhineland-model. (←) *Monument of Sugar*, 2007, installation view, World of Matter, HartWare, Dortmund, 2014. Photography: Hannes Woidich. Courtesy the artists. (↑) *Monument of Sugar*, 2007, installation view at Palais de Tokyo, Paris. Photography: Van Brummelen & de Haan. Courtesy the artists.

Tissue Culture & Art Project

Founded in 1996 by the Australian artists Oron Catts and Ionat Zurr, the Tissue Culture and Art project strives to utilise artistic means as a way to explore forward-thinking biological sciences. After training in art and design and photomedia, Catts and Zurr went on to become Research Fellows at Harvard Medical School's Tissue Engineering and Organ Fabrication Laboratory. In 2000, Catts co-founded the artistic biological research laboratory SymbioticA.

The duo's 2013 paper "Disembodied Livestock: The Promise of a Semi-Living Utopia" presented a desire to "explore the ways in which life becomes a raw matter for engineering, and how these living or semi-living engineered 'parts' persist to carry uneasy and problematic vitality".[1] By then referencing the Norse mythology behind the figure of Sæhrž´mnir—a creature killed and eaten every night by the gods, before being brought back to life for the process to continue ad infinatum—Catts and Zurr made a poetic link to the notion of renewable meat, or meat attained with no pain or misery ("having an infinite and secure source of nutrients that can never die let alone suffer"), which is still sought after and repeatedly explored in mankind's "cultural, scientific and technological ventures". *Semi-Living Steak* and the *Disembodied Cuisine* project were two results of the duo's subsequent experiments in InVitro meat creation.

Semi-Living Steak was born of the duo's residency at the same Harvard laboratory in 2000. Grown from pre-natal sheep cells (skeletal muscle), and harvested as part of research into tissue engineering techniques in utero, the original steak was developed from an unborn animal (the process is not yet wholly victimless).

Disembodied Cuisine, 2003 was no less forward thinking in its science, despite its incrementally more satirical approach to the subject. As part of the exhibition L'Art Biotech in Nantes, France, the project attempted to "poke fun at French taste and their resentment towards engineered food, and the objection by other cultures to the consumption of frogs", by presenting a meal of tissue engineered frog cells acquired in tissue of living, breathing animals: cells were taken via biopsies of the amphibious subjects, eventually creating thumbnail-sized 'steaks'. These were marinated in Calvados and fried in honey and garlic sauce, *a la Davis*—a nod to a fellow bio-artist—and served with lab-grown micro herbs to eight diners in a show of micro-degustation. The frogs (initially rescued from a farm for their use in the project) were released to a pond in a local botanical gardens.

(1) Catts, Oron and Ionat Zurr, "Disembodied Livestock: The Promise of a Semi-Living Utopia", *Parallax*, 19:1, 2013, p 101.
(→) The Tissue Culture & Art Project, view of *Disembodied Cuisine* installation, 2003. Photography: Axel Heise.

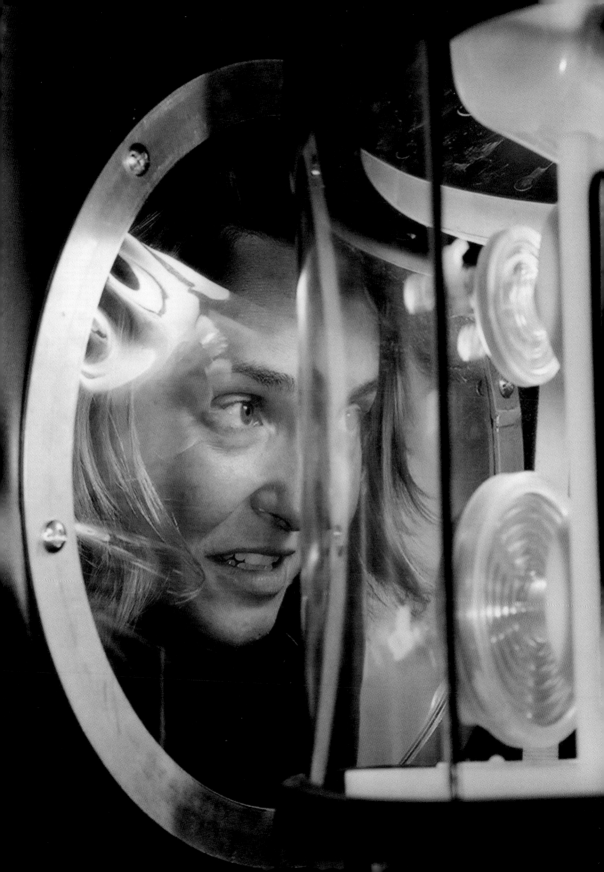

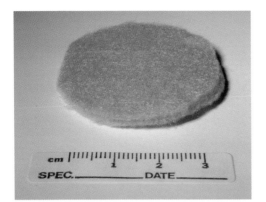

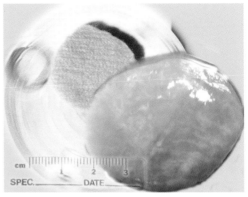

↑ *Tissue Engineered Steak No.1*, 2000, a study for *Disembodied Cuisine* (this was the first attempt to use tissue engineering for meat production without the need to slaughter animals.), pre-natal sheep skeletal muscle and degradable PGA polymer scaffold. Courtesy the artists. → The Tissue Culture & Art Project, view of *Disembodied Cuisine* installation, 2003. Photography: Axel Heise.

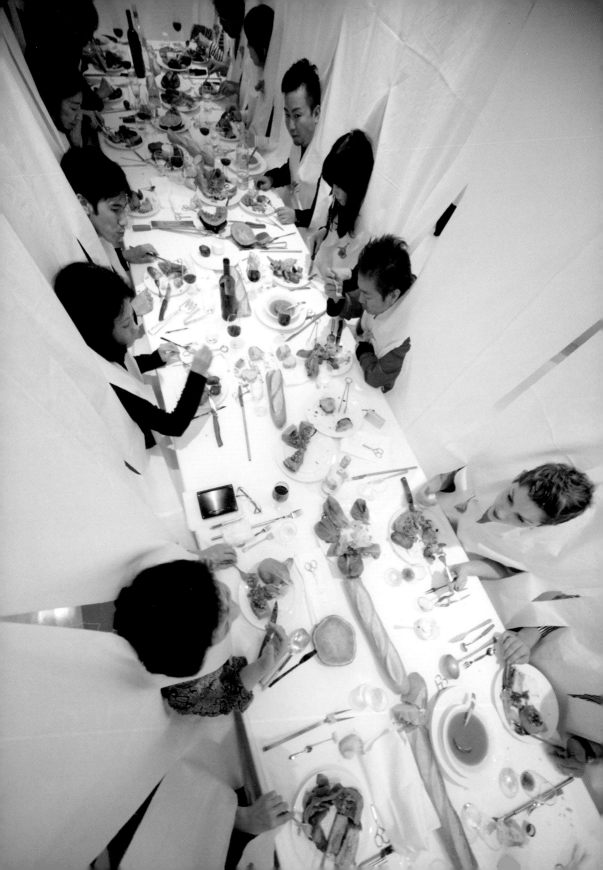

Marije Vogelzang

Amongst the many people who work with food as a medium, Dutch artist Marije Vogelzang is one of the first to specifically classify herself as an "eating designer". Vogelzang, a graduate of the Design Academy in Eindhoven, believes that "food is already perfectly designed by nature", and so meddling with aesthetic formation becomes unnecessary. However, the myriad processes — the 'verbs' — behind food, such as transporting, cooking, and most importantly, eating, are what drives her artwork.

Faked Meats is a project created by the artist as a reaction to the evolution of meat substitutes, such as soy and tofu. These products are often shaped into recognisably ubiquitous 'meat' forms, such as burgers and sausages, even though they contain no animal products. The project involved inventing fictitious animals, with origins from all over the world, and imagining ways that they could be fashioned into foodstuffs for human consumption. One such design is the "Ponti", a rat-type creature found in and harvested from Hawaii's fertile volcanic soil: "A perfect party snack", according to Vogelzang,

"because you can simply pick it up by the tail and keep your fingers clean". To further legitimise the imagined culinary use of her invented creatures, Vogelzang also visually conceptualised the way their meat would look once prepared, and what they would be best served with as a dish.

Sharing Dinner, first exhibited in The Netherlands in 2005, was another work of 'eating design' which intervened with the way a group of people engaged over a Christmas dinner. Though the participating diners were placed around the table in the regular manner, the tablecloth extended from the tabletop and over each person's head and shoulders, leaving a hole for the head and space for the arms. This brought about a sense of intimacy and interconnectedness between the diners, as each could feel if the tablecloth was pulled or moved in any direction. Food was presented on plates split into two halves, encouraging the sharing of food amongst those at the meal.

← *Sharing Dinner*, 2005. Courtesy the artist. ↑ A prepared "Ponti", *Faked Meats*. Courtesy the artist.

41

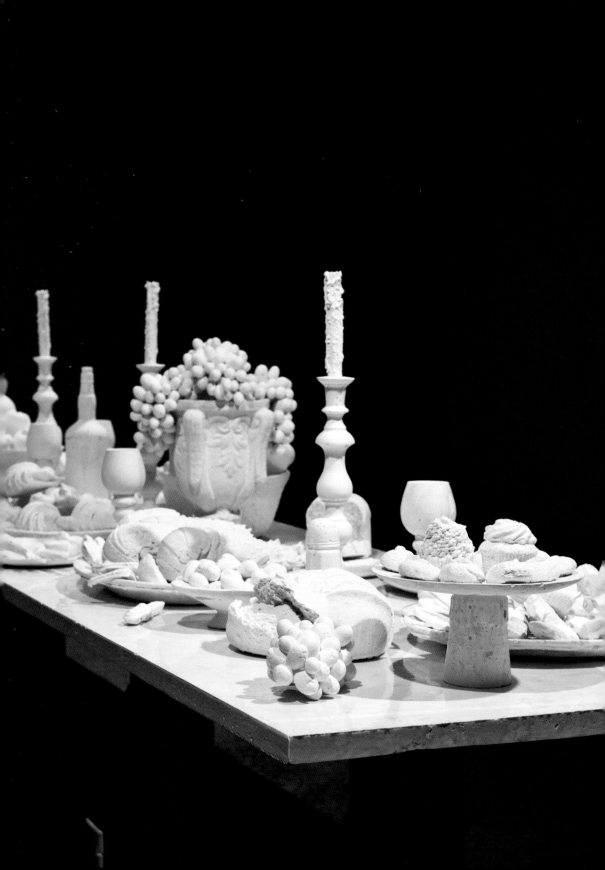

Ken & Julia Yonetani

The interdisciplinary work of Ken and Julia Yonetani explores the "interaction between humans, nature, science and the spiritual realm in the contemporary age, unearthing and visualising hidden connections between people and their environment", via performance, immersive interaction between audience and practitioner, and "inspiring responses through all five senses".[1]

Both *The Still Life*, 2011, and its de facto follow up, *The Last Supper*, 2014, are elaborate banquet sculptures constructed entirely in groundwater salt from Australia's Murray-Darling basin, a large geographical area in the southeast of the country, named after its two principle rivers. The use of salt is a metaphor for both present pointed ruminations on the problems salinity has historically posed for human civilisation. By replicating the traditional themes of still life painting and sculpture —consumption, vanity, et al—in salt, we are afforded a stark juxtaposition between notions of a luxuriant bourgeois life and the medium as a "powerful, sacred substance that maintains life", enabling food preservation whilst simultaneously causing the death of ecosystems. The material acts as a "metaphor for the rise and fall of civilisiations… and the issues of environmental decline, climate change and food security that face us today".[2]

The husband and wife duo—both born in Tokyo —have worked collaboratively since 2009, touring and exhibiting internationally, notably representing Australia in the 2009 Venice Biennale.

[1] http://www.kenandjuliayonetani.com/bio.pdf. [2] http://www. kenandjuliayonetani.com/still_life.html. ← *The Last Supper*, 2014, Murray River salt, 85 x 185 x 114 cm. Courtesy the artists.

Jennifer Rubell

After graduating from Harvard University with a BA in Fine Art, Jennifer Rubell went on to attend the Culinary Institute of America. For ten years Rubell worked as a food columnist for publications such as the *Miami Herald* and *Domino Magazine* before returning to her artistic practice. Drawing on her additional experience as an hotelier, Rubell has also written a book, *Real Life Entertaining* published in 2006. Inspired by her cross-disciplinary experience, Rubell's artistic practice fuses her dual passion for art and food.

Food is naturally Rubell's primary artistic medium, often displayed as dramatically oversized, even taking on architectural scale, or fantastically presented within strange and alluring environments. Part installation, part performance Rubell's work pointedly breaks away from standard gallery etiquette, encouraging visitors to engage with her work by touching, or even eating it. For *Icons*, 2010, Rubell held an idiosyncratic dinner gala at the Brooklyn Museum leading her guests through a series of galleries in which food was on offer, but was presented in deeply unusual circumstances. Visitors washed and prepared their own raw carrots, smothered chips with condiments squeezed from paint tubes and ate crackers, covered in cheese melted from a giant sculpture of the artist's head. The preparation of food becomes a creative act of desire fulfilment in *Just Right*, 2010—a piece inspired by the Goldilocks fairy tale—featuring a cottage within which participants were able make their own 'perfect' porridge. *Incubation*, 2011, explored the scientific process of creating foodstuffs: in an installation that mimicked a hospital nursery nurses 'incubated' and distributed yoghurt to visitors. As such, Rubell exploits the rich relationship between reality and fantasy in her tempting, yet surreal installations.

→ *Icons* (various), 2010. Courtesy the artist.

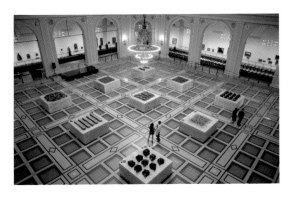

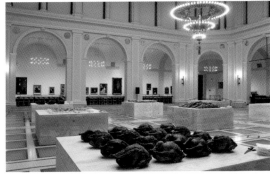

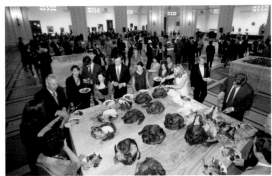

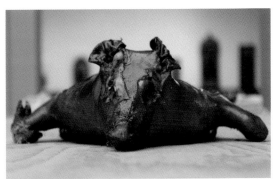

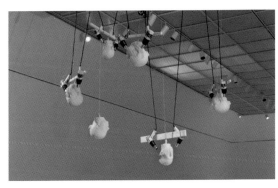

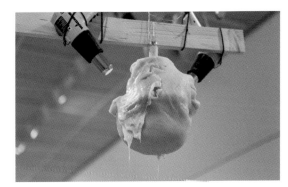

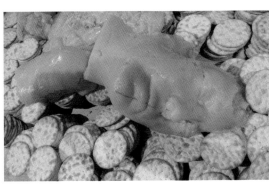

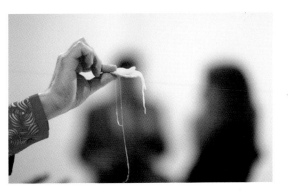

⬅ *Icons* (various), 2010. Courtesy the artist.
⬆ (top) *Incubation* (various), 2011. Courtesy
the artist. ⬆ (bottom) *Just Right* (various),
2010. Courtesy the artist.

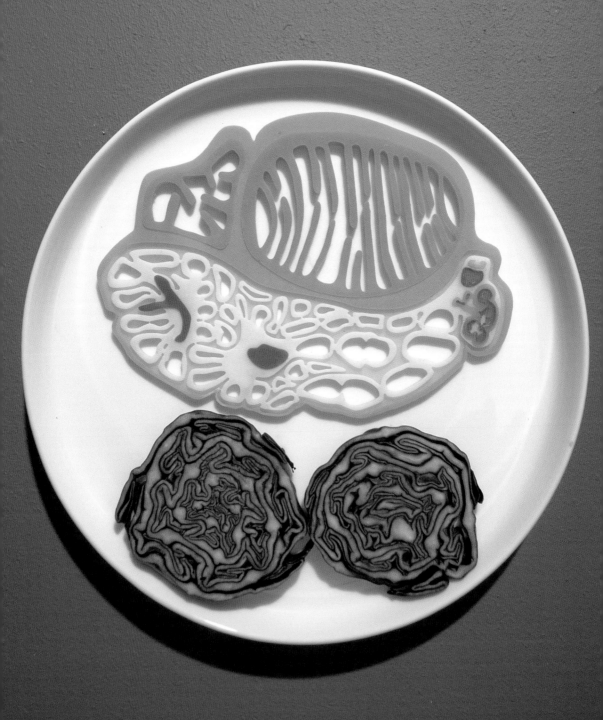

James King

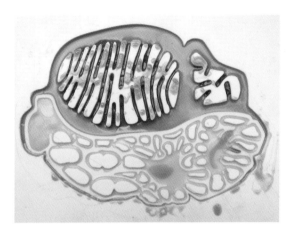

James King's 2006 project *Dressing The Meat of Tomorrow* is a reflective commentary on prospective developments in InVitro meat: advances in tissue engineering that could allow meat products to be cultivated without employing expensive and often cruel animal rearing traditions. In response to an exploratory brief issued within the Design Interactions department of the Royal College of Art (where he was studying at the time), King developed a series of proposals to examine how "we might choose to give shape, texture and flavour to this new sort of food in order to better remind us where it came from". Considering the aesthetic ramifications of this technology on culinary presentations of meat one of King's proposals included the "The Mobile Animal MRI [Magnetic Resonance Imaging] Unit": technology that "scours the countryside looking for the most beautiful examples of cows, pigs, chickens and other livestock" which are then "scanned from head to toe, creating accurate cross-sectional images of [their] inner organs". Only "the most interesting and aesthetically pleasing examples of anatomy are used as templates to create moulds for the InVitro meat (we wouldn't choose to eat the same old boring parts that we eat today). The result is a satisfyingly complicated and authentic form of food."

The resulting pieces are arresting works of design, but for the moment at least they are pieces of craft fiction: models made from fibreglass-reinforced polyester. King's aesthetically driven proposal that next-gen chefs would select animal parts on the grounds of anatomical beauty rather than homogenous practicality makes a striking balance between the starkly diagrammatic and the unctuously tangible, which "depending on your taste, [appears] just palatable enough to eat".

⬅ The finished MRI steak. Courtesy the artist. ⬆ Moulding the MRI steak. Courtesy the artist.

49

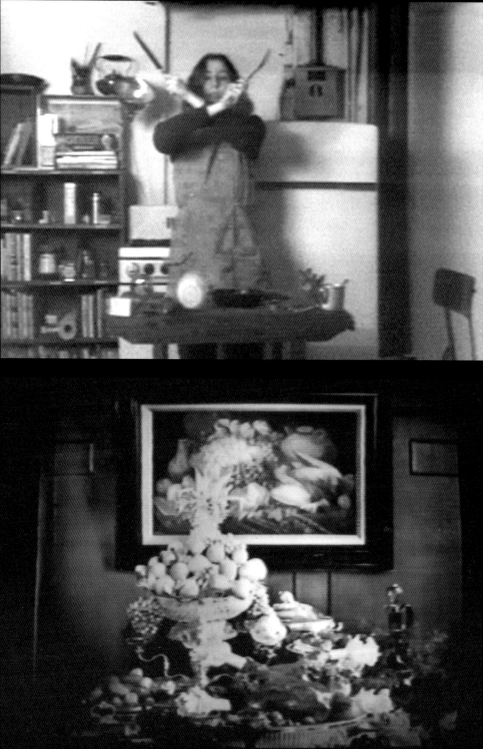

Martha Rosler

The multidisciplinary American artist Martha Rosler was born in Brooklyn, New York. Exhibiting internationally, Rosler's writing and art have been widely published. Previously she was a professor at the Städelschule in Frankfurt, Germany and, for 30 years, at Rutgers University's Mason Gross School of the Arts in New Jersey.

Rosler's work pivots broadly around notions of the everyday and the public sphere. She has written: "I want to make art about the commonplace, art that illumines social life. I want to enlist art to question the mythical explanations of everyday life that take shape as an optimistic rationalism and to explore the relationships between individual consciousness, family life, and the culture of monopoly capitalism."[1]

Her video works *A Budding Gourmet*, 1974, and *Semiotics of the Kitchen*, 1975, both apply this schema to aspects of food preparation and culture. The former sees Rosler exploring "the ideological processes through which food preparation comes to be seen as 'cuisine', a product of national culture".[2] The narrator—Rosler herself, half-hidden in shadow, empty crockery before her—explains her personal reappropriation of the tropes of certain foreign cuisines—French, 'Eastern', Brazilian, etc—and her desires to become a 'gourmet', over alternating images from travel and food magazines but also of badly undernourished children living in impoverished countries. *Semiotics of the Kitchen* sees Rosler engage in an alphabetical demonstration of kitchen implements. From its beginning as a seemingly straight expositional TV-style presentation, the video quickly becomes a subtly anarchic performance. As she demonstrates each utensil, Rosler makes non-representative gestures and the work descends into controlled chaos. Her alphabet begins with "apron" and advances through "tenderiser", but she represents letters "U" to "Z" through semaphoric gestures, ending in a shrug. As Rosler has said of the work, "An anti-Julia Child replaces the domesticated 'meaning' of tools with a lexicon of rage and frustration" skewing the viewer's expectations and transcending and transgressing the familiar meanings of "the securely understood signs of domestic industry".[3]

(1) "To Argue for a Video of Representation. To Argue for a Video Against the Mythology of Everyday Life." Handout for solo exhibition at The Whitney Museum of American Art, 1977. Published as "For an Art Against the Mythology of Everyday Life", *Journal of the Los Angeles Institute of Contemporary Art*, June–July 1979. (2) http://eai.org/title.htm?id=2547. (3) Rosler, Martha, "For an Art Against the Mythology of Everyday Life", *Journal of the Los Angeles Institute of Contemporary Art*, June–July 1977. (4) http://eai.org/title.htm?id=1545. (X) Letter "X", *Semiotics of the Kitchen*, 1975, black and white video, film still. Courtesy the artist. (L) *A Budding Gourmet*, 1974, black and white video, film still. Courtesy the artist.

Minsu Kim

Minsu Kim earned his Masters degree in Design Interactions from the Royal College of Art in 2013 and has gone on to pursue a number of artistic and research projects exploring how we interact emotionally and sensorially with technological replications of life. Kim's project *Living Food*, 2012–2013, explored this interaction within the context of food and eating, experimenting with "new culinary experiences […] through developments in synthetic biology".

Using haute cuisine and molecular gastronomy as a starting base, Kim created a series of futuristic culinary experiences in which the food was presented as a living entity and consumed alive. Employing advancements in synthetic bio-technology that allow artificial life to be stimulated in organic forms, Kim was able to make his *Living Food* literally wiggle on the plate, wave tentacles about or even appear to be breathing. With the purpose of finding out how food, and our perception of it, might change through the advancement of such technology, the artist drew spectators into his surreal vision of the future. The highly aesthetic, life-like meals encouraged the audience to make an empathetic connection with them, questioning how we might define a technologically contrived ingestible life form. As such, *Living Food* further explores Kim's fascination with how we react to life-like technology. His projects *Mechanical Seizure*, 2012, and *The Illusion of Life*, 2013, also embodied an impression of life in an attempt to contrive a sympathetic connection between man and machine, specifically through the replication of the movements and sounds of a living respiratory system.

↑ *Living Food*, 2012–2013. Courtesy the artist.

Condiment Junkie

Founded by Russell Jones and Scott King, Condiment Junkie is a London-based creative agency and "sonic art and design house" that works collaboratively with brands and corporate industry—clients have included Save The Children, Smirnoff, Heineken and Jamie Oliver—as well as artists and other creative practitioners to create installations that "examine the connections between our memories, emotions, and the sonic environment". The duo's fascinating remit is summed up thus:

> When visuals, sounds, scents and textures are blended together, our senses become heightened. The right sound can make a drink taste sweeter. The right scent can make a colour appear brighter. This multi-sensory approach is incredibly powerful. Used in marketing and branding, it has the potential to influence customer behaviour, increase enjoyment, premiumize [sic] products and promote purchase. It can help create more effective, memorable and engaging experiences and communications. We call his approach Sensory Architecture.

Bittersweet Symphony—a research project that proved that the objective perception of flavour could be modulated by different uses of sound—was a collaboration between Condiment Junkie, Oxford University's Charles Spence, and Heston Blumenthal's relentlessly groundbreaking restaurant, The Fat Duck. The Soundcloud-generated audio files above represent the two sounds created for the experiment: the upper 'sweet' file consists fluttering, high-pitched bell-like tones and ebbing, ambient washes of warm mid-levels; whereas the 'bitter' equivalent is a more constant, subterranean bass drone. The files are readily available to listen to on Condiment Junkie's blog (condimentjunkie.co.uk/blog); by alternately listening to them through headphones whilst eating or drinking something with both bitter and sweet notes—they suggest coffee—it is possible to detect noticeable changes in flavour perception (the relative files actually heighten the sense of that particular aspect) and the location in the mouth where this is generated.

⬆ Wave file visualisations of sweet (top) and bitter (bottom). Courtesy the artists.

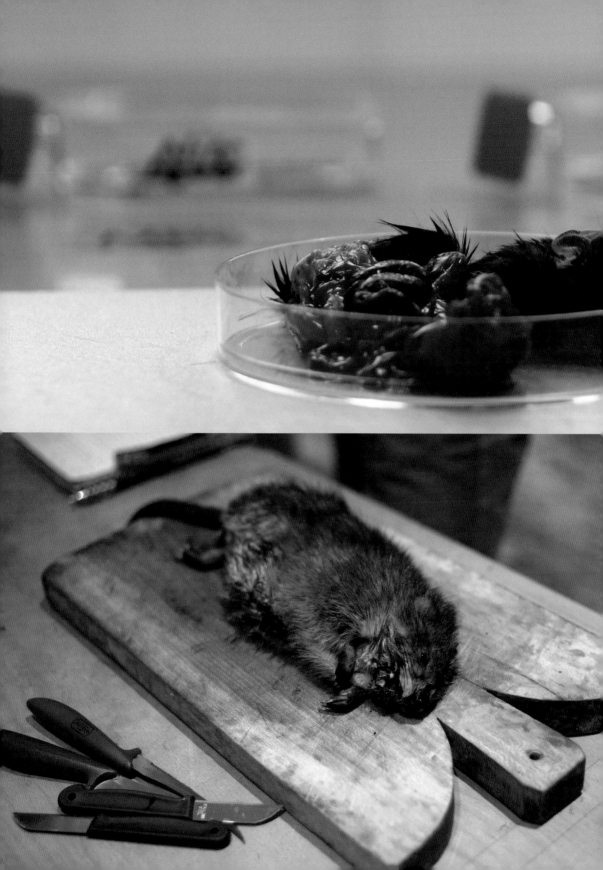

Waag Society

Though housed in one of the oldest buildings in Amsterdam, the Dutch knowledge institute known as the Waag Society Institute for Art, Science & Technology dedicates its time to investigating future cultural and technological advances. Waag Society's aim is to stimulate discussion about where society is headed through the use of participatory events, and to explore the connection between art, technology and science. In addition, there is a large emphasis on research, which they apply to developing new concepts and software applications, such as the Open Wetlab, an initiative led by artist Lucas Evers. The Wetlab was devised as a platform via which to "discuss other forms of knowledge production in addition to the scientific one via a hands-on approach (where the public itself enters in contact and interacts with the technology)… [presenting] a different interpretation of the debate on the usefulness and desirability of life sciences in society".[1]

In 2013, the Wetlab's intern Chloé Rutzerveld organised the *Other Dinner*, an "experimental and interactive dinner that investigated the meat culture of the past, the present and the future combined with a DIT Bio workshop [Do It Together—terminology that playfully points at collaboration of participants and stakeholders as distinct from the DIY Do It Yourself] to grow cells of cultured meat", comprising both a dining experience and a lecture on the future of meat consumption.[2] The workshop as a whole addressed the problems inherent in our current farming methods, and how they have become unrealistic in relation to our growing population; the dinner itself was an attempt to encourage participants to look beyond what types of meat are culturally acceptable, and to consider how we might change our eating habits to help create a more sustainable food economy. Guests at the meal were presented with animal parts to eat which are generally discarded or considered niche, such as offal, and also types of meat that are normally not considered for human consumption. Examples of the dishes devised included chicken heart and liver soup, pig's brains, muskrat and mouse liver parfait. Alongside the meal and workshop were cooking demonstrations, a class in InVitro meat creation and presentations by multidisciplinary speakers.

[1] http://www.hass.rpi.edu/pl/hass-events/adam-zaretsky-rpi-arts-phd-candidate [2] http://waag.org/nl/event/gustatory-semantics.
Ⓡ Ⓛ Courtesy Chloé Rutzerveld. Photography by Wouter van der Wal.

The American Reputation Aid Society

The American Reputation Aid Society is an interactive installation and cooking performance that aims to conduct international politics on an inter-personal level. Curated by entrepreneurial artist Carly Schmidt, the ARAS casts a satirical light on the international aid industry. By appropriating the aesthetics of existing aid-giving agencies, such as the USAID or Salvation Army, Schmidt examines the way we deal with nationality and how we encounter one another on a global level. The project is run under the auspices of Artists @ Large, a small arts business founded by Schmidt to conduct large-scale public art projects and community based initiatives.

The ARAS comprises a not-for-profit, alternative model of foreign aid, based on the economic model of a gift economy; an experimental project designed to improve, discuss, and develop better ways to be an environmentally and ethically responsible member of the global community. Taking the form of a small,

mobile kitchen, the ARAS Aid Wagon moves between public markets, where Schmitt purchases local produce with which to create examples of archetypal, homemade American food, often using recipes donated by 'concerned Americans' and archived online. Via a culinary performance, the meals are distributed personally and for free as a public invitation to engage in a conversation about food, culture, personal histories, national identity and international policy. The project directly engages its participants in an artistic experiment that deals with issues surrounding sustainable food resources, globalisation and mass media. Bridging geographic and cultural gaps, the project aims to form positive connections and international communities that can engender a constructive understanding of our increasingly global society.

↑ American Reputation Aid Society, June 2010, interactive performance. Photography: Sven Brandelius. Courtesy ARAS.

Enemy Kitchen

Iraqi-American conceptual artist, Michael Rakowitz, has been producing his ongoing project Enemy Kitchen since 2004. A piece of social sculpture, the project curates the cooking and eating of Baghdadi cuisine in order to reframe and personalise the representation of a war-torn nation and a people who, over the last decade, have been summarily categorised as 'the enemy' by much of the West.

The first incarnation of Enemy Kitchen took place at the Hudson Guild Community Center. While cooking with students—some of which had relatives in the US Army stationed in Iraq—Rakowitz would share family stories, including his family's exile from Iraq in 1946, his grandmother's love of Iraq's prized dates, and his mother's laments over the lack of Iraqi restaurants in New York. The students challenged each other and Rakowitz on the topic of war, drawing parallels with their own experiences and discussing the media's representation of the conflict. After eight weeks, they proposed to share some of their own family recipes with

the artist, an exchange that concluded in the creation of hybrid cuisine, such as Iraqi fried chicken.

This communion between supposed oppositions is also characteristic of Enemy Kitchen's later performances. Taking the form of a barbecue at The National Vietnam Veterans Art Museum on Memorial Day, 2009, Rakowitz cooked Iraqi kofta on the grill with American veterans in collaboration with the Chicago chapters of the Iraq Veterans Against The War (IVAW) and Vietnam Veterans Against The War (VVAW). In 2012 Enemy Kitchen also featured in Feast: Radical Hospitality in Contemporary Art, an exhibition at the Smart Museum of Art in Chicago. This time operating as a food truck, the project produced regional Iraqi food cooked by different Iraqi cooks of a nearby restaurant and served by American veterans of the Iraq War, a cultural juxtaposition that sparked conversation between participants and diners alike.

⊙ Enemy Kitchen. Courtesy Michael Rakowitz.

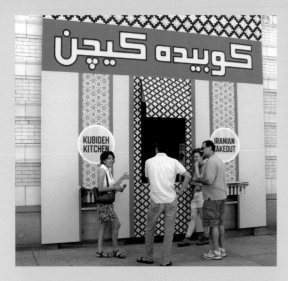

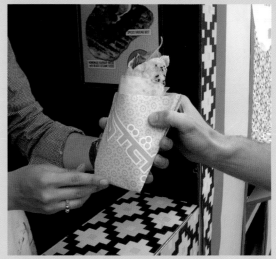

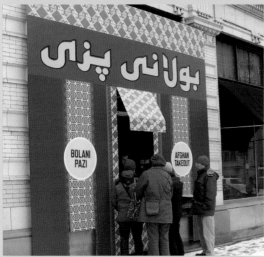

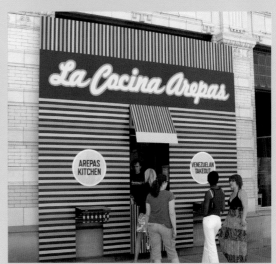

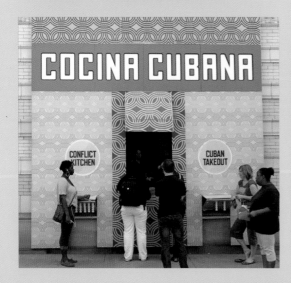

Conflict Kitchen

Pittsburgh-based artist Jon Rubin produces participatory projects that intervene in community and public life. An art professor at Pittsburgh's Carnegie Mellon University, Rubin's multidisciplinary practice creates situations that aim to "reimagine individual, group and institutional behaviour". The context for these community projects is wide ranging. Previous endeavours include *The Independent School of Art*, 2004–2006, a school that ran on a barter-based tuition system in the San Francisco Bay Area, and *The Waffle Shop (Talk Show)*, 2009–2013, which simultaneously functioned as a working restaurant and continuous live talk show event featuring the business' patrons as guests.

In 2010 Rubin co-founded *Conflict Kitchen*, in collaboration with Dawn Weleski in the East Liberty neighbourhood of Pittsburgh in 2010. Now based in the Schenley Plaza area on the University of Pittsburgh campus, the take-out restaurant completely changes its aesthetics and menu every six months to a different national cuisine, specifically those stemming from countries currently in a conflict with the United States government. To date, *Conflict Kitchen* has served food from Iran, Afghanistan, Cuba, Venezuela and North Korea.

Through the project, the serving of food has become a way to engage communities in storytelling activities and form an otherwise absent public space that encourages interaction between cultures. The North Korean version of the restaurant was developed with input from several North Korean defectors. To connect visitors of the restaurant with the cultural context of their lunchtime take-out, Rubin and Weleski designed food wrappers that contain printed interviews with their North Korean collaborators on a variety of subjects from culture and politics. The restaurant is also the location for a series of events that seek to directly engage customers in discussion and debate. One particular programme featured a Pittsburgh local woman acting as an avatar for an Iranian man, answering questions from other Pittsburghers on his behalf as he communicated through her from Iran.

⬅ Conflict Kitchen. Courtesy Jon Rubin and Dawn Weleski.

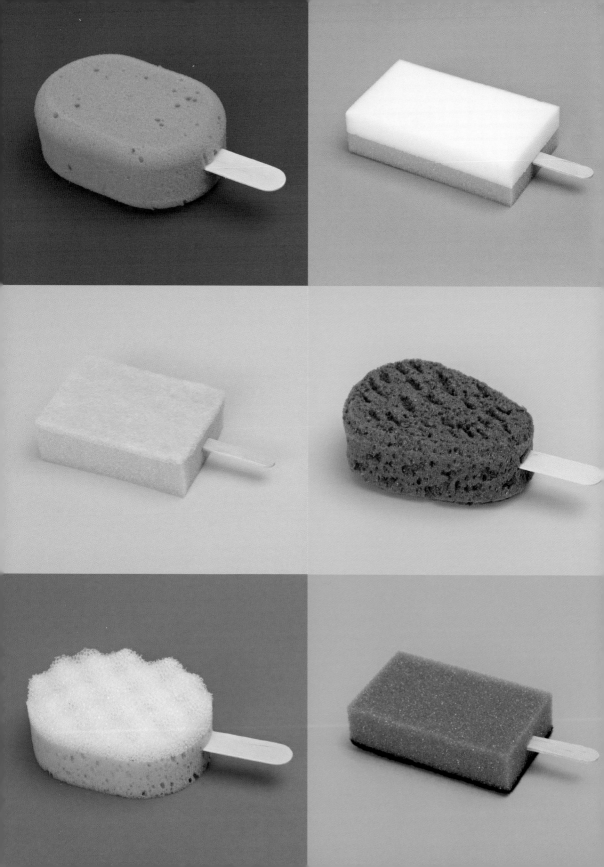

PUT
PUT

Formed in 2011, PUTPUT is an anonymous Swiss/Danish duo based in Copenhagen. Much of the practice's art revolves around the re-configuration of everyday objects into something completely different. PUTPUT creates work, they say, to challenge "perception and recognisability" of objects through "distinctly staged scenarios and tableaux that underline a metaphysical relationship to the material world". As a result, the final pieces are often simple, yet still compel double takes from their audiences.

One such project is their 2012 photographic collection, *Popsicles*. Despite the nomenclature, the images are actually of repurposed sponges, with popsicle sticks protruding from them. Presentation is stark and lurid, each infantilisingly multicoloured example displayed against a monochromatic background.

"Both products represent different aspects of everyday life and are recognisable in their own right", PUTPUT says. "They are morphed into a fictional replica creating a visual double take and a dysfunctional bi-product." The design blog Design Boom summed up the remit of the project thus: "From something that represents an activity that is perhaps not so enjoyed, the collective have managed to create some graphically flamboyant pieces that are a cheerful iteration of something very much loved."

⟵ ⟱ *Popsicles*, 2012. Courtesy the artists.

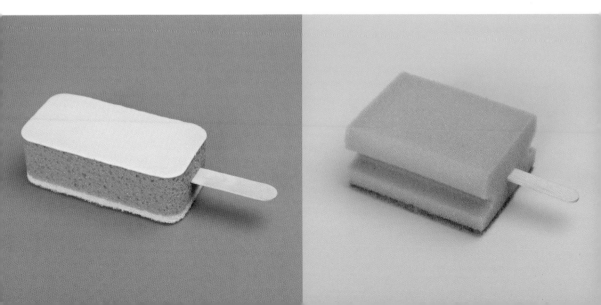

Preparation

II

Bompas
&
Parr

Sam Bompas and Harry Parr founded the food design studio Bompas & Parr in 2007. The design partners first gained notoriety for creating works of art using the medium of jellies — they originally self-defined as "jellymongers" — but the studio soon expanded, and now creates large architectural structures and sculpture designs, making "immersive flavour based experiences" that have included breathable clouds of gin and tonic, a chocolate climbing wall, and the Guinness Taste Experience at the Guinness Storehouse in Dublin, Ireland.

One of these projects was *Tutti Frutti*, created for London's Kew Gardens in the summer of 2013. The project emerged out of a mutual curiosity shared by the partners — namely, that there are over 70,000 edible fruits in the world, the vast majority of which we never have the opportunity to eat. The multi-part architectural installation was built on the Gardens' lake, and after the water was dyed blue, a large Pineapple Island was constructed as the centrepiece of the installation. On the island was a collection of plants, which collaborating sonic artist Mileece equipped with electrodes to capture their electromagnetic output. She then converted this into music, providing a de facto 'soundtrack' for the installation. To reach the giant pineapple, participants climbed into rowing boats, which they could then manoeuvre underneath the island to experience the Banana Grotto — a tunnel filled with a cloying banana mist. Visitors were also equipped with specialised glasses, which gave the entire installation a Tutti Frutti appearance.

Another project which has received considerable attention is the recent *Cooking With Lava*, 2014, in which the duo cooked a meal over — surprise — lava, at a heat of 2,100 degrees Fahrenheit. Bompas explained that he first tried cooking with lava at Sakurajima, an active volcano in Japan. He described this trip as the inspiration for the project: "[The experience] gave me goosebumps. The intensity of the experience meant that on returning to the UK, I immediately sat down with Harry Parr to plot. We wanted to see if there was a way to create synthetic lava so a wider audience could experience the wonders of food cooked this way."[1] Bompas lauded the cooked meat as the best he had ever tasted.

[1] http://www.slate.com/blogs/the_eye/2014/08/01/bompas_parr_join_forces_with_robert_wysocki_of_syracuse_university_to_barbecue.html. → *Tutti Frutti*, 2013 (from the accompanying publication *Tutti Frutti with Bompas & Parr and Friends*). Photography: Nathan Pask. Courtesy the artists.

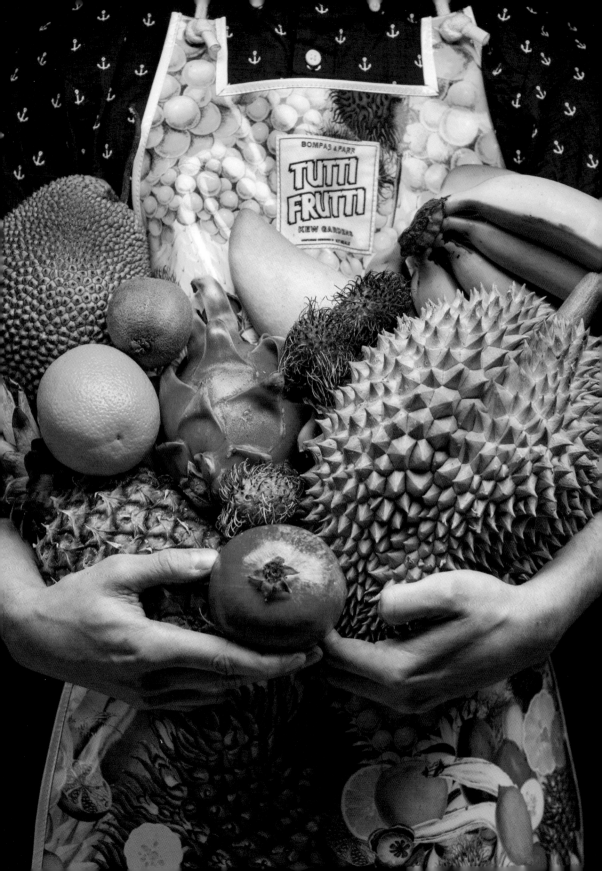

Tutti Frutti Pineapple Island/Banana
Grotto, Kew Gardens, 2013. Photography:
Ann Charlott Ommedal. Courtesy the artists.

↑ → *Cooking with Lava*, 2014.
Courtesy Sam Bompas.

Adam Zaretsky

Adam Zaretsky, PhD is a self-proclaimed "Wet-Lab Art Practitioner mixing Ecology, Biotechnology, Non-human Relations, Body Performance and Gastronomy", staging "lively, hands-on bio-art production labs based on topics such as: foreign species invasion (pure/impure), radical food science (edible/inedible), jazz bioinformatics (code/flesh), tissue culture (undead/semi-alive), transgenic design issues (traits/desires), interactive ethology (person/machine/non-human) and physiology (performance/stress)". He runs a public life arts school, The Vivoarts School for Transgenic Aesthetics Ltd or VASTAL; a biotech research corporation, NADL Inc; a psychic fertility clinic, PsyFert; a religion — Lineago — on a micronation (name withheld from public); and a rubber stamp bioethics consortium called Bioart Ethical Advisory Kommission, or BEAK.

Zaretsky's work touches on myriad themes — from art history to philosophy, through science, food and pop-culture — and whilst elements of humour are a constant throughout both his artistic and scientific practices, "his endeavours are grounded in a very serious and complex understanding of biologic and genetic issues that are very much a part of contemporary society.... Zaretsky's "bio-artwork is motivated by his own set of ethical quandaries prompted by past history",[1] a

factor that has earnt him the status of something of a bio-futurist provocateur at times: for instance, in 2010 he was stopped from leading a workshop at the Arts Electronica Festival, in which members of the public were invited to alter the evolutionary trajectory of an otherwise regular zebrafish by use of a 'gene-gun'.

The 2011 project *Tattoo Traits* was a collaboration between Zaretsky, Zack Denfeld, Helen Bullard and Simon Hall, which set out to examine the viability of DNA tattooing, and the health and legal hurdles contained therein. Mixing a plethora of appropriated foodstuffs, yeast and human samples created a 'new medium' of mixed biological substances, from which DNA was extracted using a rudimentary method involving the addition of hand cleanser and human centrifugation (in this case, attaching containers of the mixture to a belt and spinning like a dervish). By using an adapted tattoo gun, this "novel sequence of hybrid DNA" could then be tattooed into the nucleus of a living cell and reincorporated into a living genome; something "statistically improbable, but conceptually possible".[2]

(1) http://www.hass.rpi.edu/pl/hass-events/adam-zaretsky-rpi-arts-phd-candidate (2) http://www.artsprofessional.co.uk/magazine/feature/artists-and-scientists-under-microscope. (←) Tattoo Traits. Courtesy Adam Zaretsky and Simon Hall

The Cloud Project

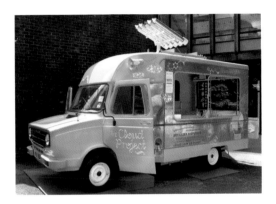

The Cloud Project comprises a re-appropriated and modified ice-cream van, developed to present a series of experiments to make "clouds snow ice-cream". According to the collaborating organisers, the then-RCA students Zoe Papadopoulou and Cathrine Kramer, the project was "inspired by developments in nanotechnology and planetary-scale engineering, [pointing] to new possibilities where we develop the means to conform the global environment to our needs".[1] Or, as Dr Andrew Maynard — Chief Science Advisor for the Project of Emerging Nanotechnologies, Woodrow Wilson International Center for Scholars — states more simply, it used "art and design to engage people [with] nanotechnology and geoengineering in a simple, enjoyable and appealing way".[2]

The hypothetical science worked thus: by taking the theories behind cloud seeding — a method of weather modification that takes advantage of the natural Bergeron Process of formation of precipitation, in which ice nuclei (usually silver iodide) are blasted into existing cloud formations — the duo could then add an ice nucleation gene (inaZ), isolated from certain bacteria (such as *Pseudomonas syringae*) into a *Saccharomyces Cerevisiae* cell (a kind of yeast often used in the food industry), which would also encapsulate the relevant ice cream flavours using encapsulating techniques for microorganisms. At high enough quantities, "it is hypothesised that the sensory experience of eating ice-cream will be achieved by the resulting snowfall".[3] In summary, a van blasting ice cream particles into the sky, resulting in a blizzard of gelato.

The refit of the van — including cloud generators and a roof-mounted, industrial-strength water spray — was an inspired piece of retro-chic design by Kramer and Papadopoulou, enough to initiate engagement and conversation on nanotechnology and geoengineering with a curious and receptive public, even if the scientific concept behind the project is a little way ahead of tangible realisation: "It'll be a while", Maynard states, "before you'll see strawberry-clouds over the English countryside".

(1) http://callmecat.com/index.php/page/view/the_cloud_project. (2) http://2020science.org/2009/07/05/geoengineering-the-plane-with-nanotechnology-icecream/#ixzz37RoDF8BN. (3) http://callmecat.com/index.php/page/view/the_cloud_project. ← ↑ *The Cloud Project,* 2009–2011. Photography: Garry Hamil. Courtesy the artists.

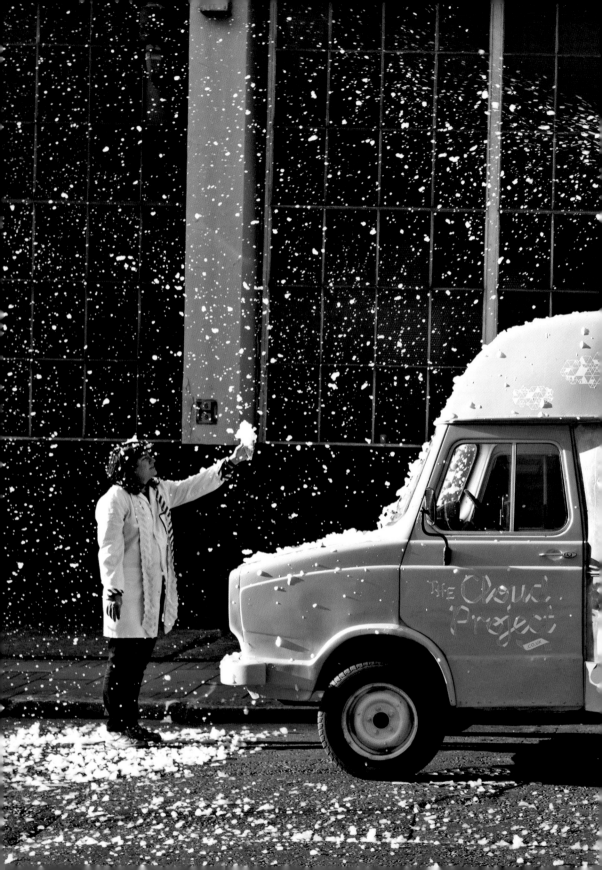

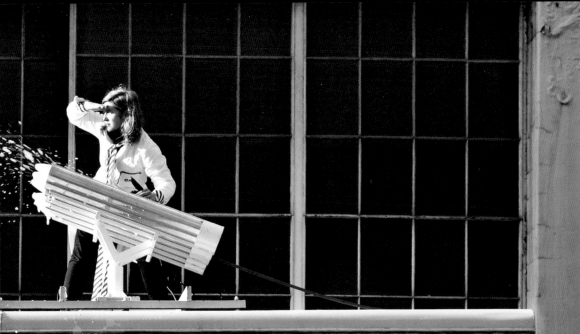

CLOUD INGREDIENTS
bacteria
salt particles
water droplets
ice crystals
dust particles
carbon particles

MENU
SPECIALS

Utilising advances in nanotechnology
and cloud seeding techniques.
ARTILLERY DISPERSED
ICE CREAM INGREDIENTS
MAKE
clouds snow ice cream!

Susan Mogul

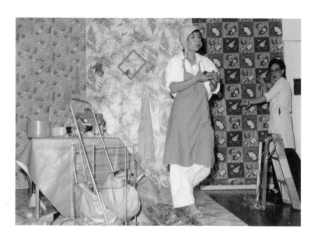

Susan Mogul is an American multidisciplinary artist and filmmaker. In between attending the Boston Museum School of Fine Arts and the University of California at San Diego she studied with Judy Chicago and Allan Kaprow at CAL ARTS, and, at the Feminist Studio Workshop at the Los Angeles Woman's Building, where she first began applying the themes of feminism and sexuality to her work.

Mogul's 1980 performance piece *Design for Living* is a rumination on notions of the "tension of fitting in" as well as a comment on the artist's relationship with her mother (though Mogul posits that this is an idea to which only she was privy). Over a period of 30 minutes, Mogul builds an ever-growing salad. Simultaneously, an "interior decorator", Jerri Allyn, colour-coordinates Mogul as she works, setting and altering the space around the artist "... hanging strips of wallpaper, tying aprons on Mogul and taking them off, bringing out another table when the vegetables begin to fall off the first one, pouring out glasses of club soda, tacking vegetables to the wall, holding up small frames to turn objects and actions into Works of Art", whilst remaining completely silent within her world for the piece's duration.

Mogul, on the other hand, barely stops conversing with the audience. Speaking about her dislike of iceberg lettuce, she drops a few leaves on the floor; Allyn quickly appears with a green rug, dustpan and broom, tacks green wallpaper on the floors and walls, wraps the artists in a green apron and sits her at a table festooned with a green tablecloth. When she sucks on a lemon, she pauses to regale the audience with a story about the fruit, whilst Allyn appears with a yellow bowl.

The salad making, according to Mogul, represents a "messy life activity" which constantly changes in opposition to interior decorating, "an ideal arrangement of objects in which everything fits and blends".

↑ Susan Mogul and the "decorator" Jerri Allyn perform *Design for Living*, 1980. The performance is coming to a close, as the floor and wall are decorated. Photography: Len Jenshel. Courtesy the artist.

Antipode

While not 'art' per se, Rob Dunne's *Antipode* construction broaches the borders of a consciously sensory approach to coffee preparation. Effectively a coffee ice cube over which whiskey is poured, the drink was designed to "engage the drinkers' focus on taste by requiring sipping at intervals, rather than rapid consumption".

The recipe is as follows:
Brew using an Aeropress.
18 grams, ground for cupping/French press.
235ml water, temperature 37.5 °C.
Inverted submerged method.
Double paper filter.
Time 35–40 minutes brew and press.

Extra ingredients:
20ml 1 to 1 Simply Syrup using a light. muscovado (or sugar of choice).
5ml Madagascar Bourbon Vanilla Extract.

Process:
Mix all liquid ingredients together.
Set as 25ml measures in ice tray and freeze.

To present, simply serve ice in appropriate drinking vessel, with a 25ml measure of your preferred whisky. The whisky measure should be equal to that of the ice cube.

"The diffusion of the coffee cube into the whisky," Dunne states, "gradually inverts the ratio of each of the drinks individual components, resulting in a glass where the taste balance constantly shifts and ultimately ends at the beginning's antipode." [An *antipode* meaning two points diametrically opposite each other on the globe.]

The taste change is subtle but consistent, with the aim for the drinker being to consider discerningly the different ingredients as the coffee and alcohol mix.

(↑) *Antipode*. Photography: Giulia Mulè. Courtesy the artist.

Paul McCarthy

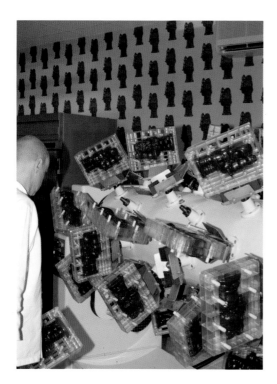

over the 2007 Christmas period. Overseen by the author and Master Chocolatier Peter P Grewling, McCarthy's nascent company produced 1,000 edible recreations of his infamous, 25-foot-high bronze sculpture *Santa holding a butt plug* exhibited at that year's Art Basel exposition (itself a nod back to McCarthy's performances in the 1990s, in which he reimagined the populist folk figure as a degraded octogenarian spattered with food, blood, and other bodily effluents), albeit in this instance in a more innocuous "Santa With Tree And Bell" guise. Of course, McCarthy — ever the mischievous provocateur — failed to tweak any of the original design: "You may not see it at first", *The New Yorker* suggested, "but once you do you keep seeing it". The chocolates — a cool whole pound in weight and ten inches tall — sold for $100 a piece.

The Maccarone's transformation was extensive and comprehensively legitimate. Electrics and plumbing were replaced to meet New York City Code requirements, industry-standard chocolate manufacturing equipment was installed, and the gallery was split into four distinct areas necessary to each stage of the manufacturing and commercial process: for the manufacture, packaging and storage of the products, and a McCarthy-designed retail store to sell them in. "Turning a gallery into a shop — there's something I like about that", McCarthy stated at the time. "But is it a chocolate company or a sculpture? Is it people doing a job or is it a performance, which you watch through a window? I view the whole thing as sculpture."

"I've made a number of pieces about the butt plug", Paul McCarthy conceded to *The New Yorker* in an interview a number of years back. "I like that it looks like a Christmas tree, and also like a Brancusi, or an Arp. As an artist, you look for things that have multiple meanings."

So it was with the LA-based artist's Peter Paul Chocolates LLC project, in which he converted the 6,000 square foot Maccarone Gallery into a functioning chocolate factory and retail store

↖ *Peter Paul Chocolates*, 2007, Chocolate Factory, Installation view, Maccarone Gallery, New York. Courtesy the artist and Hauser & Wirth. → *Chocolate Santa with Butt Plug* (prototype), 2007. Courtesy the artist and Hauser & Wirth.

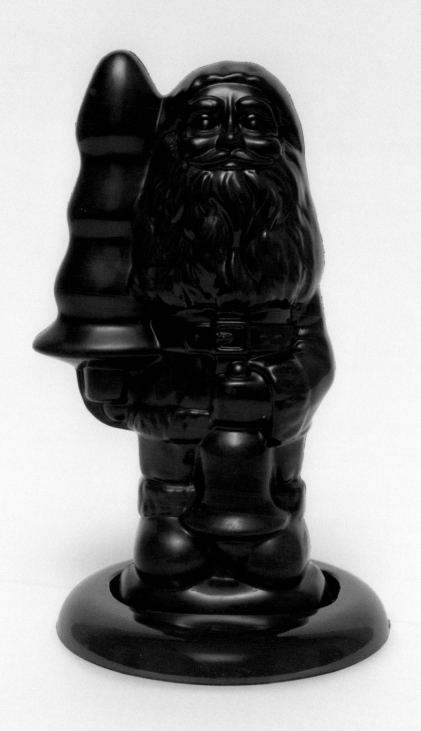

Elsa Lambinet

Born in 1987, French designer Elsa Lambinet is an honours graduate of the Ecole Cantonale d'art de Lausanne with a Masters of Advanced Studies in Luxury. In addition to having worked for acclaimed artist Phillippe Starck's studio and L'Oreal, Lambinet has created multiple original projects, many of which draw on notions of luxury. Her designs include a specialised wall tape measure to record the heights of growing children, and a propeller-shaped coffee stirrer for the dissolution of sugar.

Another of Lambinet's forays into luxury design was completed for her Masters diploma. Entitled *Sweet Play*, the project consists of deconstructed, bite-size chocolates that can be mixed and matched with added ingredients in several different ways. The dark chocolates contain holes for fruit; the milk chocolate for nuts; and the white chocolate includes a space to accommodate liquids. All three chocolate types are hollowed out, so that one can insert a flavoured wafer into the middle. The project, inspired by the creative building of Lego bricks, is fun and whimsical, challenging etiquette and breaking rules around playing with food. Yet the experience is still wholly luxurious: the chocolates are sourced from the artisanal workshop of La Chocolaterie des Tuillerie du domain Lenchieux in France. The project, developed entirely by Lambinet, eventually progressed into a bona fide commercial company, from which the chocolates can still be bought.

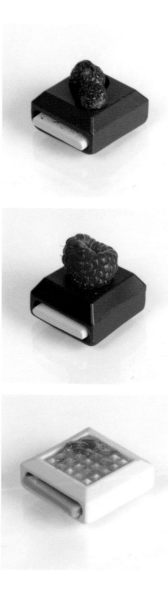

⊙ *Sweet Play.* Courtesy the artist.

Henry Hargreaves

Though never formally trained as a photographer, New Zealand native Henry Hargreaves has forged a career behind the camera after years as a high end model in front of it, coupled with working in the food industry. With clients including such highly esteemed brands as Ralph Lauren, *NY Magazine*, *GQ*, *NYLON*, Boucheron, *Marie Claire*, and Sagmeister, Hargreaves has established himself as a premier photographer with multiple independent projects to his name. Based out of a studio in Williamsburg, Brooklyn, Hargreaves has shifted focus to food as a medium for his photography on multiple occasions, including via *No Seconds*, a collection of photographs showing the final meal requests of American death-row inmates, and *Food of the Rainbow*, which portrays traditional foods in all of the colours of the rainbow.

Deep Fried Gadgets is another salient example. The project, a series of photographs depicting various electronics after they had been cooked in a deep fryer, is a whimsical commentary on the technological consumerism of the twenty-first century, and the tendency for many in the developed world to line up year after year for the newest technological playthings. "I like to play with food and the juxtaposition of different worlds", Hargreaves says. "Also, I see similarities between tech culture and fast food. Quickly devoured and then discarded."[1] One may wonder how the artist was able to afford the electronics only to drop them into hot oil, but Hargreaves did not use real gadgets, he forged them out of 'foamcore'. Spanning many years, a wide variety of items were depicted including an Apple iPad right alongside a Nintendo Gameboy.

[1] Rundie, Michael, "Deep Fried Gadgets: Artist Henry Hargreaves Cooks Beloved Tech for Art", *The Huffington Post*, 11 June 2012, http://www.huffingtonpost.co.uk/2012/06/11/deep-fried-gadgets-artist-henry-hargreaves_n_1586527.html. ⬅ ⬆ *Deep Fried Gadgets*, 2012, archival pigment prints. Styling: Caitlin Levin. Courtesy the artist.

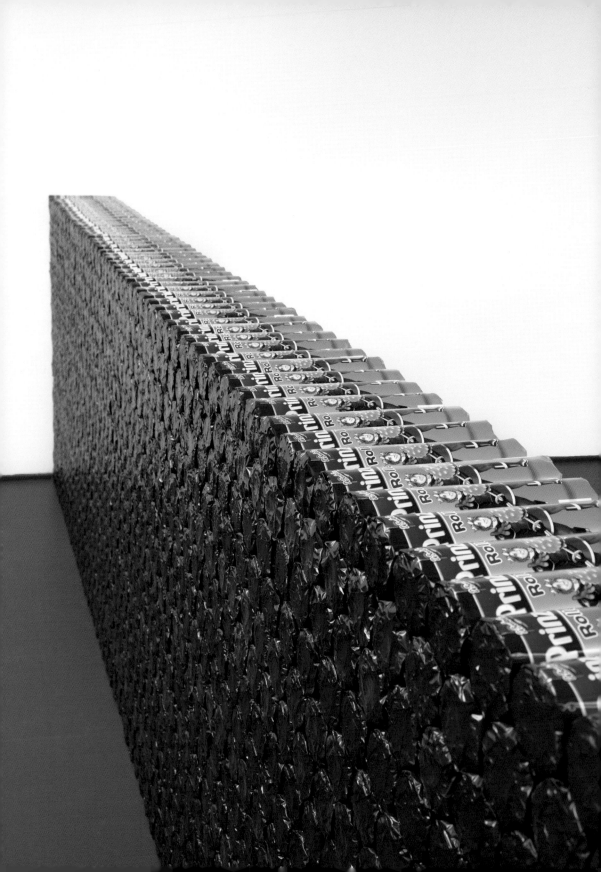

Thomas Rentmeister

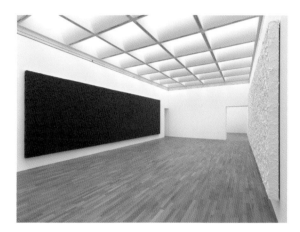

Born in Germany in 1964, Berlin-based Thomas Rentmeister has garnered extensive acclaim for his sculptural work. Occasionally defined as a "dirty minimalist" for his "distinctly 'impure'" approach to form, Rentmeister appropriates everyday materials in unorthodox ways, reappropriating them into works of art, whilst avoiding any attempt to change the aesthetic form of his chosen media.[1] His famous *Refrigerator* sculptures, slathered in baby cream, are a fitting example: perfunctory objects, stickily repurposed in the name of cerebral aesthetic expression. For Rentmeister, "art is much more than just a formal exercise—sculpture (and its materials) is an everyday phenomenon, we just aren't always aware of the aesthetic quality of sugar cubes and handkerchiefs".[2]

Rentmeister developed further this use of banal source materials in his project *Objects. Food. Rooms.*, 2011, a major site-specific collection first presented in Bonn before opening at the Perth Institute of Contemporary Arts in Western Australia. The collection of works saw Rentmeister engaging in fresh discourses

around our reaction to and attitudes toward the artist's use of foodstuffs. The installations ranged from the geometrically architectural—see the walls of *Prinzenrollen* biscuit packets—to the unctuously biological in his fusion of seeping Nutella and chicken wire (referred to as "voluptuous" in Amy Barrett-Lennard's catalogue text). States Barrett-Lennard, "The sheer volume of these foodstuffs and their placement within the often strictly 'food free' environment of the gallery… allow[s] a kind of visual disassociation. We are, after all, used to encountering such nourishment in more modest quantities and at the kitchen table."[3]

(1) Panhans-Bühler, Ursula, "Sweet Heaviness and Gravitational Sweetness", in *Thomas Rentmeister. braun / brown*, (cat.) Ostfildern: Kölnischer Kunstverein, 2002, p 60. (2) http://www.kunstmuseum-bonn.de/en/ausstellungen/rueckblick/info/ex/thomas-rentmeister-900/?PHPSESSID=e08b0242280bd207fed0ab02ef0fc815. (3) http://www.thomasrentmeister.de/en/home/bibliography-texts/barrett-lennard-objects.html. ↙ *Untitled*, 2013, packets of chocolate biscuits (Prinzenrollen), approx 107 x 466 x 25 cm. Courtesy the artist. ↑ *Untitled*, 2011, Nutella on laminated chipboard, 350 x 1200 x 16 cm. Photography: Bernd Borchardt. Courtesy the artist.

Christina Agapakis
& Sissel Tolaas

Christina Agapakis is a synthetic biologist whose research explores the role of design, ecology, and evolution in biological engineering. Sissel Tolaas is a multidisciplinary "professional in-betweener" and—according to *Dazed and Confused*—"olfactory icon" whose research and work in the realm of smells, how we communicate about and through odours, draws on her varied background in mathematics, chemical science, linguistics and languages, and visual art. Paired together for a Synthetic Aesthetics residency, the duo sought to explore the ways that both recreated and isolated the natural world through both biological and chemical means.

The result was *Self Made*, an installation exhibited at the Science Gallery, Dublin, in 2013, and a project that explored the "possibilities for a relational synthetic biology through the practices of cheesemaking".[1] Put very simply, the project sought to create cheese from human sweat, "reflecting an individual's microbial landscape in a unique cheese"—an initiative perhaps less idiosyncratic when one considers that many of the most pungent cheeses are hosts to bacteria closely

related to those responsible for the distinctive odours of ours feet and armpits.

Agapakis and Tolaas inoculated swabs from human hands, feet, noses and armpits in organic whole milk, which was left to incubate overnight at a temperature of 37° Celcius. The milk curds were then strained and pressed in to small rounds of cheese. Initially, eight were made—each with bacterial origins taken from members of the Synthetic Aesthetics team—though a further 11 were created for the Science Gallery exhibition, with bacteria sampled from cheesemakers, scientists, food writers, artists and curators. Varying in texture, colour and odour, the cheeses were considered both scientific and artistic objects, "challenging the observer to confront the microbiological aspects of their food and their body, while offering a unique medium in which to study the interactions of microbes and the volatile compounds that they produce".

(1) https://dublin.sciencegallery.com/growyourown/selfmade
(↑) Christina Agapakis and Sissel Tolaas, *Self Made*, part of GROW YOUR OWN at Science Gallery Dublin. All images courtesy the artists. (→) Sissel Tolaas holds a cheese that is left to age.

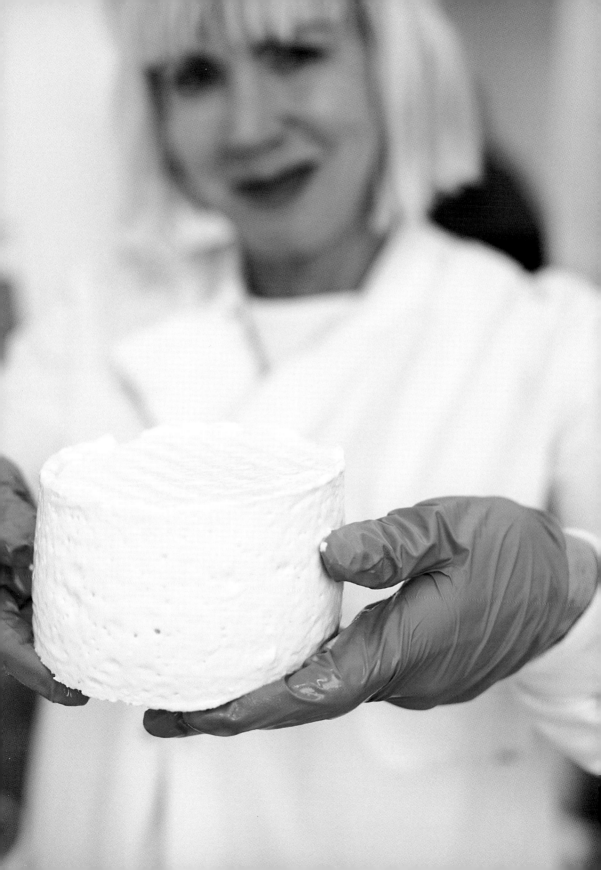

↑ Sissel Tolaas and Christina Agapakis
with cheese from *Self Made*. → Ingredients.

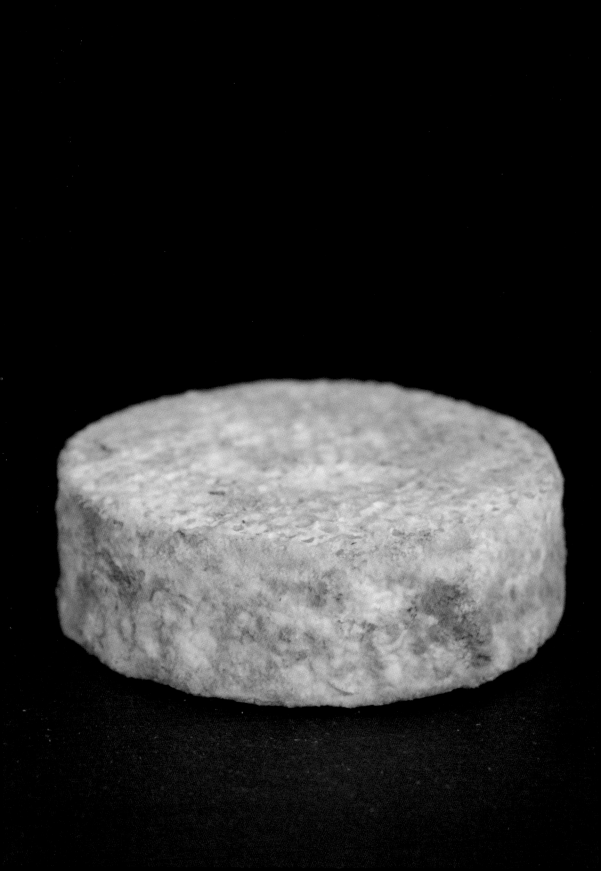

⊖ Ben's finished cheese. ⊙ Assorted
personal bacteria. ⊙⊙ Michael's and
Christina's finished cheeses.

Sarah Lucas

Sarah Lucas graduated from Goldsmiths College in 1987, subsequently taking part in the seminal group exhibition Freeze which launched the careers of several key British artists of that generation, including Damien Hirst and Angus Fairhurst. In 1993 she collaborated with Tracey Emin on *The Shop*, a six-month venture on Bethnal Green Road. Her work is often sexually suggestive, utilising everyday objects, photographs and collage to create visual puns on sex and gender. *The Guardian* journalist Aida Edemariam stated in a 2011 article that "Lucas was the wildest of the Young British Artists, partying hard and making art that was provocative and at times genuinely shocking".[1]

Lucas' *Two Fried Eggs and a Kebab* sees the artist appropriate food products to a workaday allegory of the female body, in which metaphors are made bluntly literal. First exhibited in Soho in 1992 — the work explores issues of sexual objectification and examines our perception of desire and human fascination with sex, "a set of viciously reductive symbols for a naked woman, with congealed yolks for nipples, and a half-eaten pile of meat in place of genitals".[2]

Au Natural, 1994, is a similarly humorous take on still-life art with crude, quietly shocking representation of the human body and sex. A grimy looking mattress sits propped against a gallery wall. On the left are positioned an old metal bucket and two melons wedged into rips in the mattress; on the right, a phallic positioning of a cucumber and two oranges. The diorama is ludicrous, but also highly charged; the objects "forming a bleak tableau redolent of a squalid one-night stand in a bedsit".[3]

① Edemariam, Aida, "The Saturday Interview: Sarah Lucas", *The Guardian*, 27 May 2011, http://www.theguardian.com/theguardian/2011/may/27/the-saturday-interview-sarah-lucas. ② Sooke, Alastair, "Sarah Lucas: funny, compelling and really, really good", *The Telegraph*, 3 October 2013, http://www.telegraph.co.uk/culture/art/art-reviews/10350461/Sarah-Lucas-funny-compelling-rude-and-really-really-good.html. ③ Sooke, Alastair, "Sarah Lucas: funny, compelling and really, really good", 2013 ⬅ *Au Natural*, 1994, mattress, melons, oranges, cucumber, water bucket, 84 x 167.8 x 144.8 cm. Copyright the artist, courtesy Sadie Coles HQ, London. ⬇ *Two Fried Eggs and a Kebab*, 1992, table, fried eggs, kebab, photo, 151 x 89.5 x 102 cm. Copyright the artist, courtesy Sadie Coles HQ, London.

The
Decorators

The concept for the temporary Ridley's pop-up restaurant first materialised when architect Zoe Chan of Atelier ChanChan approached the design studio, The Decorators—an interdisciplinary group comprising of an architect, landscape architect, spatial designer, and psychologist—in September of 2011, with the question of what to do with a 25-metre space within Dalston, London's Ridley Road Market. A decline in traffic had seen large-scale supermarkets divert a growing share of commercial attention away from the family-run traders year on year. In an effort to revitalise the market and introduce a fresh way of engaging with the local food economy, The Decorators and Atelier ChanChan created Ridley's Restaurant, a barter-based restaurant open for all of September in 2011.

An entirely self-sufficient enterprise, the restaurant relied on customers to supply the ingredients for the lunch and dinner cooked each day. In order to reserve a place at the restaurant for lunch, prospective diners would head into the markets to purchase one of several ingredients laid out on the restaurant's daily 'shopping list'. They would then deliver these ingredients to the Ridley's kitchen, where the resident chefs would turn them into that day's dishes. For dinner, customers paid £15 for a table reservation, receiving £5 back in the form a market voucher, which they could then use to purchase ingredients for lunch the next day. This created a cyclical, self-sufficient system that supported both the economy of the restaurant and the markets.

The transactional system of Ridley's was not its only unique element—the two-storey restaurant featured a dinner table connected to a pulley system, delivering cooked meals from the kitchen area on the first floor to the communal dining area on the second. Customers, who were encouraged to sit for dinner half an hour in advance, sat around communal tables, encouraging spontaneous conversational engagement (to further allow for this, diners were only allowed to bring a single companion).

⬆️➡️ Photography Dosfotos. Courtesy Decorators & Atelier ChanChan.

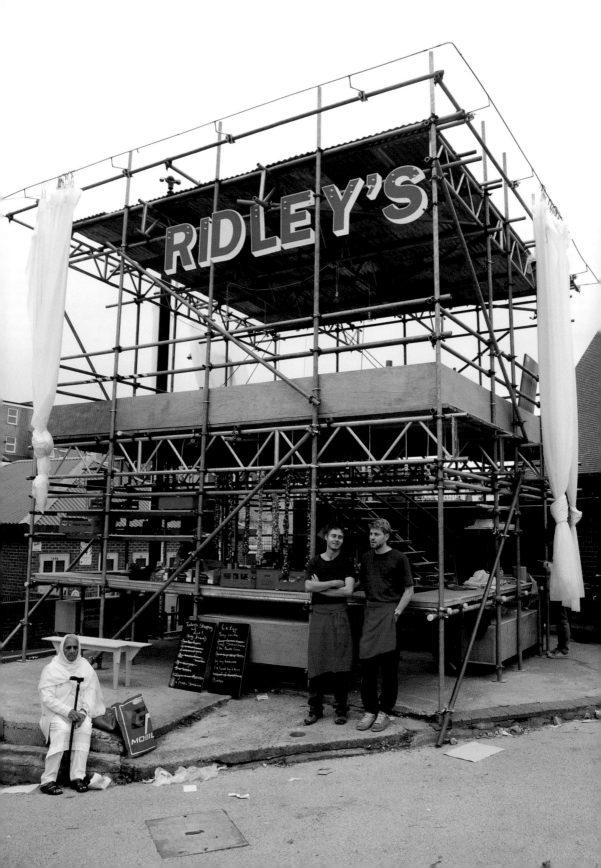

EIDIA

"Eating is a bad habit."
 Quentin Crisp

EIDIA—pronounced "IDEA" and derived from the Greek "*eidos*" meaning, unsurprisingly, "idea"—is the collective pseudonym adopted in 1986 by the East Village-based multidisciplinary duo Melissa P Wolf and Paul Lamarre. The practice is self-defined as "consistently an interdisciplinary / intermedia endeavour exploring the dynamics of art politics, social spaces, and the environment".

Food Sex Art / The Starving Artists' Cookbook was a dual print and video project developed over five years between 1986 and 1991. Drawing on the privatisation of the New York Art scene and the emergence of the 'art star', Wolf and Lamarre looked to explore the personas and approaches of their featured artists by way of gastronomic engagement—their lifestyle as exemplified by what he/she cooked and ate. The resulting series of filmed interviews and ad hoc cookery demonstrations ran to nine hours worth of edited video—with each artist given three minutes apiece—though the disseminated *Highlights Tape* featured extracts of 25 practitioners over an hour and 43 minutes.[1] Those chosen included Peter

Beard, Louise Bourgeois, John Cage, Leo Castelli, Lisa Cieslik, Papo Colo, Tony Conrad, Quentin Crisp, Alan Shields, William Wegman and Lawrence Wiener. Each clip acts as a fascinating, if at times banal, insight into that most quietly revealing of daily practices, replete with a mix of anecdotal conversation and intimate ritual: from William Wegman's irreverent 'popping' of a Vitamin C tablet (which ends up all over the floor), through Lawrence Wiener's childhood recollections, to Papo Colo's preparation of super-frugal pre-Colombian cuisine, and John Cage's macrobiotic, perennial "Soup Des Jours".

The tangible *Cookbook* itself—a lo-fi, ring bound tome—contains all 161 artists recipes and is illustrated with a variety of kitchen-based portraits of, or works by, each practitioner, and is held in myriad notable museum and gallery collections around the globe.

(1) This is specifically the 'edited' version of the work; there are literally hundreds of hours of unedited video footage which constitutes the FSA/SCA archive. EIDIA also preserved all original artworks, handwritten and typed recipes (to exact scale as in the book), correspondences and ephemera. (→) (rows, top to bottom) *The Starving Artists' Cookbook Video Series: the Highlights Tape*, film stills, TRT 103 minutes, with Popo Colo, Louise Bourgeois, John Cage, and William Wegman. Courtesy Paul Lamarre and Melissa Wo.

Sarah Illenberger

Born in Munich and based in Berlin, Sarah Illenberger is a multidisciplinary artist known for her witty images constructed from an eclectically wide range of everyday objects and materials. She uses everything from tires to paper to food, which she then arranges to be photographed for display. Intersecting art and design, Illenberger's work is exhibited in galleries, illustrates magazines and publications, operates as advertising, fashion shoots and exists as show window displays or installations. Due to her ability to transform and reappropriate recognisable objects within attention grabbing compositions, Illenberger has also been commissioned by several high profile clients including *Time*, *New York Times Magazine* and Nike, creating roses of many colours, portrait busts out of food or human organs out of wool.

One such project is *Tutti Frutti*, 2011–2013, which Illenberger was inspired to create after visiting the market environments of Tuscany, Italy. Noticing abstracted images of other objects in and around the produce, the artist sought to create design-focused, tangible amalgams of this collaged material. The result was a rich, contrasting collection of images that pair design-blog style visuals with laconic humour: cutting open a pomegranate to reveal its seeds before attaching a grenade pin to the top of the fruit; polishing up skinned beetroot bulbs to appear as rubies; attaching brush handles to halved globe artichokes; or repositioning anatomically dissected cauliflower hearts as brains.

→ *Zwiebel*, 2011–2013. → *Rubine*, 2011–2013. → *Granite*, 2011–2013. → *Rosenkohl*, 2011–2013. → *Artyschoke*, 2011–2013. → *Birne*, 2011–2013. → *Blumenkohl*, 2011–2013. All images courtesy the artist.

Kitchen Lab

In an attempt to devise new ways to prepare and eat food, design and research professionals Carl and Betsy DiSalvo started the Kitchen Lab as part of the 2012 Open Field residency at the Walker Art Center. Involving collaborations with myriad designers, artists, researchers and educators, the initiative aimed to use food preparation as a way to explore our cultural identity and as a way to express social beliefs. The project also considered what components 'make' a kitchen, exploring the influence of engineering, art, culture, history and craft. The 'lab' itself was a public workshop and mobile kitchen where people could participate in new kinds of food experiences. Kitchen Lab thereby addressed how communities conceive of kitchens, and asked how we could redesign and rethink the kitchen's role in our lives. Betsy DiSalvo posited the aims of the project in a contemporary interview with the Walker Art Center magazine: "By looking at the kitchen, rather than just the product of the kitchen, we're hoping to get a deeper understanding of how culture, history, and social structure shape the food we eat".[1]

One of the Lab's first organised events was *Amuse Bouche*, in which participants were encouraged to create an eponymous micro-dish—a one bite meal—which they felt represented the state of Minnesota. The project was developed with an aim to provoke people into conceptualising a link between food and ideas, and to offer a unique, creative gastro-sensory experience. Participants were expected to make these amuse bouches using "taste cards", which contained one word descriptions, such as "sweet" or "sour", and phrase cards bearing sentiments evocative to Twin City residents, such as "Fireflies in a jar", "Algae on a lake", "Slush in your boot", and "Minnesota nice".

[1] Bielak, Suzy and Sara Nichol, "Why Food Now? Kitchen Lab sparks a conversation of food activism's moment", *Walker Magazine*, 18 June 2012, http://www.walkerart.org/magazine/2012/food-activism-kitchen-lab-carl-betsy-disalvo. ← ↑ *Amuse Bouche*. Courtesy Carl and Betsy DiSalvo.

mischer' traxler

Studio mischer'traxler comprises the Vienna-based
duo of Katharina Mischer and Thomas Traxler,
both graduates of the IM-masters department at the
Design Academy Eindhoven. Since initiating their
collaboration in 2009, the duo have created design
with a "focus on experiments, context, and contextual
thinking". Their work has been exhibited all over the
world and projects are in the permanent collections
of several museums.

Reversed Volumes is a project comprising a collection
of bowls, shaped by the imprint of a fruit or vegetable,
originally designed for the trans-European pop-up-
store-cum-workshop Foodmarketo in 2010. The
concept is relatively simple: a collection of bowls
formed through the setting of casting material between
fruits, vegetables and containers; the bowls thus
adopting the imprint of the filling materials, presenting
the aesthetic identity of each organic subject in detail
and from a "new point of view". This manual process
resulted in a delicately elegant, idiosyncratic product,
and the series includes casts of apples, lemons, oranges,
cherimoyas peppers, aubergines, napa cabbages, sugar
melons, cauliflowers and cabbages.

The Spanish design brand PCM put the designs
in to semi-industrial production into 2013.

→ mischer'traxler studio, *Reversed Volumes*, 2010/2013, food safe
resin, Ø10 – Ø22 cm. Produced by PCM Design. Photography: Jara
Varela. Courtesy the artists. → → mischer'traxler studio, *Reversed
Volumes*, 2010/2013, food safe resin, Ø10 – Ø22 cm. Produced by
PCM Design. Photography: Jara Varela. Courtesy the artists.

Florent Tanet

Through his minimal yet vibrant photographs, Florent Tanet poeticises the mundane, transfiguring ordinary objects or situations into impressive motifs.[1] Working in series, Tanet predominately focuses on still lives, taking inspiration from Scandinavian and Dutch photographers such as Carl Kleiner, Wyne Veen, Samuel Henne and Scheltens & Abbenes.[2] In his concentrated treatment of everyday objects, luxuriating in their surfaces and giving weight to their materiality, Tanet transforms ordinary things into curiosities worthy of consideration. Tanet's over attention to the object informs a striking and attractive image—one that grabs the attention of the viewer.

This talent for arresting simplicity has earned Tanet commissions from numerous magazines, such as *The New Yorker*, *M le Monde*, *Fast Company* and *Citizen K*. The photographer's singular style operates at an intersection between disciplines—fashion, sculpture, design and fine art photography—no doubt due to Tanet's own split practice; with qualifications in textile design and applied fashion, Tanet's photographic work merges with fashion in his design practice.

In *A Colourful Winter*, 2013, the subjects of Tanet's studies are fruits and vegetables "developed on the cutting board":[3] carved, peeled and rearranged into playfully surreal, sculptural still lives. Light backgrounds expand the dimensions of the image, experimenting with colour, shape and scale to create cheerfully whimsical tableaux. In Tanet's hands, produce forms patterns and sculptures and the kitchen becomes a visual playground. Commissioned and displayed to great effect during early 2013 by La Grande Epicentre de Paris, a luxury boutique in the Le Bon Marche department store in Paris, Tanet's humorous and colourful images were a reprieve to winter's normally sombre palette. For contrast, Tanet has expressed an interest in working with frozen food in the future: "Cool colours and translucent, frozen pictures could be very poetic."[4]

(1) www.florenttanet.fr. (2) http://www.la-cremerie.fr/photo/interview-de-florent-tanet. (3) (4) https://www.finedininglovers.com/stories/florent-tanet-food-photography/. (→) (→) (→) Courtesy Florent Tanet.

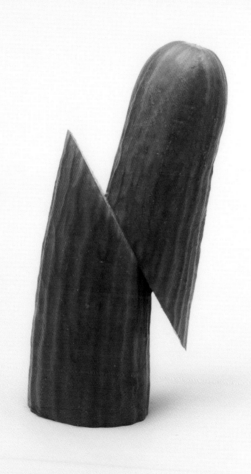

Dinner

III

Center for Genomic Gastronomy

Zack Denfeld, Cathrine Kramer and Emma Conley's Center for Genomic Gastronomy is an artist-led think tank that conducts independent research into human food systems. Through this research, the Center engages in the mapping of food controversies, develops alternative culinary prototypes and suggests methods to engender more sustainable, biodiverse and aesthetically exciting food systems. The Center operates internationally, collaborating with scientists, artists, culinary professionals and enthusiasts to produce exhibitions, meals, public lectures and publications.

To examine how ecological systems are affected at a global scale by agriculture, selective animal and plant breeding and the choices that inform how and what we eat, the Center have organised an ongoing series of international 'dinner' events. Entitled *The Planetary Sculpture Supper Club*, the first event occurred in Portland, OR, US in 2011 and has since travelled to Lisbon, Portugal and Bangalore, India, amongst other locations. Presenting alternative eating systems, experimental cuisine and recipe collections cultured from scientific research and technological advances, these dinners engage participants in debate over how selection biases and preferences in food consumption allow certain genomes to propagate, putting pressure on the diversity and distribution of life.

Further examining the effect of genetic manipulation on human food systems, *The Glowing Sushi Cooking Show*, 2010, utilised the transgenic GloFish™ as a food stuff in order to confront diners with a commercially available genetically modified animal and prompt a debate about the ethics and unexpected consequences of scientific research. The project demonstrates how technological advancements filter through systems of use, migrating from a business innovation in the life sciences to a trademarked brand of fluorescent zebrafish sold as pets and then, potentially, to a lab-grown fish sold as meat. *The Spice Mix Super Computer*, 2012, was also a technologically contrived expansion of culinary knowledge and understanding. The mobile food machine allowed users to invent new spice blends from millions of possible and hitherto untried combinations. With their ability to imaginatively extend ideas into new mediums and locations, the Center for Genomic Gastronomy suggested the potential uses of spices for communication, novel culinary experiences and even gateways to new consciousnesses.

⊙ *Cobalt-60 BBQ*. All images courtesy Center for Genomic Gastronomy.

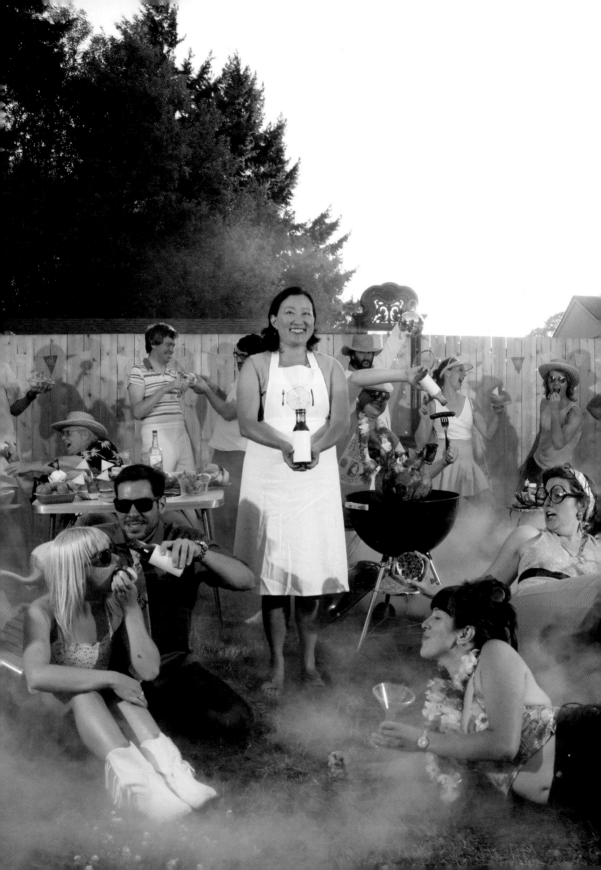

Zack Denfeld and Cathrine Kramer.
Glowing Sushi. De-Extinction Deli,
Planetary Sculpture Supper Club Portland.

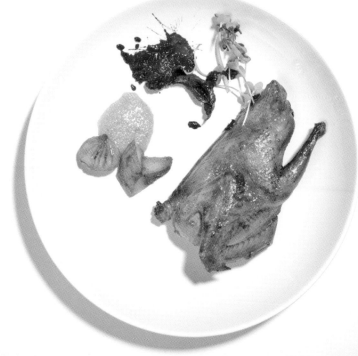

PLANETARY SCULPTURE
SUPPER CLUB

- LISBON -

The Planetary Sculpture Supper Club explores the ways planetary patterns change in response to how and what humans eat.

The Planetary Sculpture Supper Club is a project by the Center for Genomic Gastronomy. It is part of the exhibition *The Real and Other Fictions*, curated by Mariana Pestana for Close, Closer. 2013 Lisbon Architecture Triennale.

Every Saturday dinners are hosted by Carlos Vaz Marques who has invited a special guest to be the Marquis for the evening.

All recipes are developed by the Center for Genomic Gastronomy in collaboration with Heather Julius, chefs António Henriques, Fábio Bernardino, Pedro Bettencourt and Vasco Alves, and the culinary schools of Hospitality and Tourism of Estoril, Lisboa and Setúbal. Visitors can join the dinners upon reservation at close-closer.com.

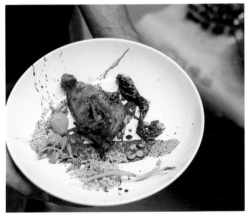

(←) Menu, Planetary Sculpture Supper Club Lisbon.
(↑) (top) Planetary Sculpture Supper Club Portland.
Photography: Ryan Fish. (↑) (bottom) De-Extinction
Deli & Wheat Wars, Planetary Sculpture Supper Club
Portland. Photography: Ryan Fish.

125

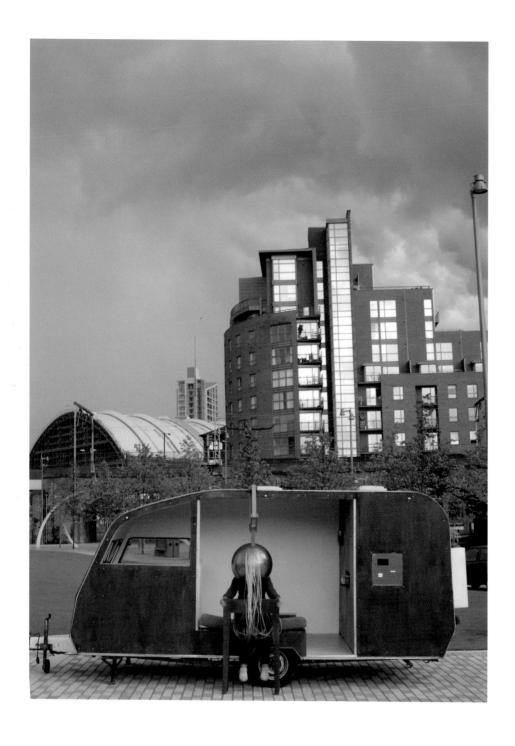

⬆ ➔ *Spice Mix Super Computer.*

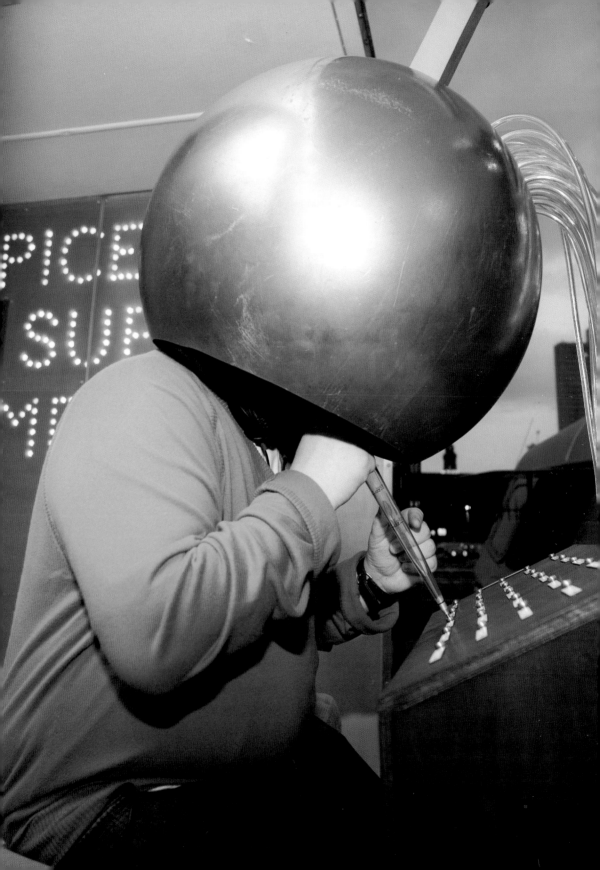

Bonnie
Ora Sherk

Since the inception of her practice in the 1970s, the San Francisco and New York City-based artist Bonnie Ora Sherk has utilised public space for purposes of artistic expression. As an "environmental performance sculptor", Sherk creates actions integrated into environments, sometimes using found environments, other times creating them, but always assimilating them with performance, which, in recent years, has evolved to include community programmes and/or hands-on interdisciplinary learning.

One of Sherk's earliest performances, *Public Lunch*, was performed in the Lion House at the San Francisco Zoo. One Saturday afternoon in February 1971, patrons of the zoo headed to the Lion House to watch the lunchtime feeding of the animals. As resident tigers and lions tore into raw meat, the visitors were surprised to see Sherk eating her own lunch in a separate enclosure. In a cage adjacent to that of the other animals, the artist was served a meal—catered by a well-known restaurant—at a formally set table complete with white linen tablecloth.

In addition to the spectacle of juxtaposition between the artist, a vision of civilisation at her sophisticated formal dining table, and the beasts viscerally tearing at their food (one can imagine the noises created in the process), *Public Lunch* also raises issues of feminine identity—a topic that was at the forefront of young female artists' minds in 1971. Sherk, encaged in the zoo, is on show for all to look at and objectify, a point she emphasised in her choice of typically 'feminine' attire (a dress and high-heeled boots).

Since 1981, Sherk has been developing an evolving transformative project, *A Living Library*, which provides a powerful framework, and series of strategies and methodologies for making place-based, ecological change in communities and schools.

⊕ *Public Lunch*, 1971, San Francisco Zoo. Copyright Bonnie Ora Sherk. Courtesy the artist.

128

Daniel Spoerri

The eminent Swiss sculptor, writer and performance artist Daniel Spoerri was born in 1930 in Galaţi, Romania, his parents fleeing to his adopted homeland in 1942. Following an immersion in the theatre, the young Spoerri moved to Paris in 1959 and soon after became a founding member of the Nouveaux Réalistes.

Food quickly became a major trope of Spoerri's work, an element he would come to refer to as "Eat Art". This particular aspect of his experimentation is exemplified in the relief sculptures he labelled *tableaux-pièges* or "snare-pictures". Fixing objects found in spontaneous organic arrangements—often the things left behind after a meal: dirty plates, cutlery sporadically dropped on the table, half-empty red-rimmed wine glasses, stale bread segments—Spoerri snared them in a moment of time. Then, by changing the position of the arrangement in relation to the viewer—what was horizontal becomes vertical when hanging from the wall—he transformed ordinary meal-time detritus into engaging art works: part documentary pieces, part theatrical props on a performance set.

Kichka's Breakfast, 1960, was the first piece in this line of investigation. An unexpected study of an intimate relationship is created in the coffee pot, tumbler, crockery, eggcups, eggshells, cigarette butts, spoons and tin cans sitting atop a wooden chair which is itself suspended on the wall. The items, left behind after a breakfast Spoerri shared with his then-girlfriend, act in this form as much indexical links to the time and the experience as any photograph of the scene could.

↑ *Kichka's Breakfast I*, 1960, wood chair hung on wall with board across seat, coffee pot, tumbler, china, egg cups, eggshells, cigarette butts, spoons, tin cans, etc, 36.6 x 69.5 x 65.4 cm. Philip Johnson Fund. © 2014. Digital image, The Museum of Modern Art, New York/Scala, Florence.

Elizabeth Willing

"You can manipulate confectionery so heavily", Australian artist Elizabeth Willing says, "and people will still want to eat it". A fine arts graduate of Queensland University of Technology and based in Brisbane, Willing often places sweets at the centre of her artwork because of the reactions they bring out in people; her key interests lie in the "sensory elements of food", and the "ideology that accompanies these materials".

One notable use of confectionary in Willing's artwork is her installation *Goosebump*, created originally for Fresh Cut at Institute of Modern Art Brisbane and as part of the Sugar, Sugar exhibit at the Brenda May Gallery in Sydney, 2010. The piece consists of *pfeffernüsse* biscuits evenly lining the gallery wall. The biscuits were attached to the wall with royal icing, one of Willing's favourite materials, which she calls "edible cement". The biscuits were ready for consumption, but guests were not informed of this as they entered the gallery. They needed to use their senses to find the

work, which was camouflaged on the wall within an obtuse wallpaper pattern. Soon enough, the audience began to eat the work, revealing the brown interior of the *pfeffernüsse*. The result was a height graph of sorts, with only the biscuits at the hardest to reach points remaining intact at the end of the display. The name of the work is a reference to the gingerbread house in Hansel and Gretel; the house in the story is "an incredible sugar house many children, including myself, would have loved to have stumbled across", Willing says. "But then there is the witch inside who wants to eat them; the cannibalism is expressed in the title of the work, eating goosebumps off the wall."

Willing's 2012 work *Stew* was also created for Sydney's Brenda May Gallery and managed to draw an equally visceral reaction from viewers. The piece is a large-scale collage of different images of stews and casseroles from vintage cookbooks, dating from the 1970s and 1980s. These images, which Willing believes to be a part of "the uninspiring food photography" of the era, "make for a revolting spew-like blob far removed from the pleasures of a homecooked meal". Though stews and casseroles are generally known as hearty, satisfying meals, the images presented have the opposite effect, visually repulsing viewers. Willing's inspiration for *Stew* came, she says, from "a housemate of mine who used to make [one] a few times a week", who would "more often than not leave it on the stove overnight, and perhaps for a day or so to get a bit rancid before throwing it in the bin or out in the yard. I learnt to hate the never-ending stew, and old casserole cookbooks were a physical representation of that".

← *Goosebump*, 2010, Pfeffernüsse biscuits and royal icing on wall, 900 x 400 cm. Courtesy the artist. ↑ *Stew*, 2012, stew and casserole images from cookbooks, glue, 300 x 200 cm. Courtesy the artist.

Barbara Smith

Barbara Smith was born in Pasadena, California, in 1931. Whilst studying at the University of California in Irvine, she founded the experimental gallery F-Space with Chris Burden, Nancy Buchanan and other like-minded artists. It was here that her nascent career as a performance artist was initiated, exploring themes as diverse as "the body, food, nurturing, female desire, heterosexual relationships, sexuality, religion, spiritual transformation, love, and death".[1]

In the 1969 piece *Ritual Meal*, Smith created a dinner at the home of the art collector and philanthropist Stanley Grinstein and his wife Elyse, at which 16 guests dressed in surgical garbs were served a six-course meal served and consumed with surgical implements, and featuring foodstuffs resembling raw organs and flesh. Onto the walls were projected films of open-heart surgery, anatomical systems, and images of galaxies and nebulae, plus films of the waiting staff hiking in the nude, amongst other themes, whilst a looping soundtrack of the sound of a human heartbeat overlaid with live synthesiser churned in the background.[2] The servers were silent throughout, never informing the diners on how to proceed.

Smith herself took on a shamanic role as overseer to proceedings—a traditionally masculine undertaking here gender-flipped—in order to emphasise "the gendered interiority of 'home'" and an "interiority of feminine action that often goes unnoticed—the very thing exposed by Smith in [the] ritual".[3] According to the artist herself, *Ritual Meal* "created the dilemma of seeming to be consuming a body while simultaneously experiencing union with the cosmos".[4]

(1) Calder, Diane, "Barbara T. Smith", Pomona College Museum of Art, 2005. (2) Esslinger, Sandra, "The 21st Century Odyssey Part II: The Performances of Barbara T Smith" *X-tra*, Vol. 8 No. 1, Fall 2005. (3) Esslinger, Sandra, "The 21st Century Odyssey Part II: The Performances of Barbara T Smith". (4) http://www.barbaratsmithart.com/category/performances/ritual-meal/. (↑) *Ritual Meal*, 1968, performance. Courtesy the artist and The Box, LA.

Michael
Portnoy

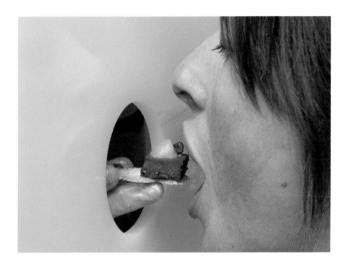

Since launching into the American lexicon with his "Soy Bomb" stunt at the 1998 Grammy Awards, Michael Portnoy has been lauded for his subversive, absurdist performance art. The stunt, a wild dance and gestation behind Bob Dylan's performance of "Love Sick", was only an introduction to Portnoy's unique representation of participatory artistic experiences. A self-described "Director of Behaviour", Portnoy's works fall into a category he calls "Relational Stalinism", the changing of the normality of participation in art so that the artist controls, and constrains, the participants to act in a certain manner.

Portnoy's *WANDBISS*, staged at Art Unlimited Basel in 2007, continued this style of artwork. Subtitled *a fine biting experience*, *WANDBISS* (German for "biting room"), consisted of a chamber within which four participants at a time attempted to eat bites of food offered from one of multiple holes in the wall. The bite-sized food was controlled by an operator on the other side of the wall, who would offer and then pull back the food at their discretion, subjecting participants to an edible game of Whack-A-Mole (or perhaps something more luridly sexual). Participants were also disallowed from using their hands in the experience, and were forced to consume the bites of food only with their mouths. The eight-course meal, crafted by Basel chef Christina Ramseier, was fed through the walls with skewers or edible utensils such as vegetables or breadsticks. Due to the frantic nature of the exhibit, participants were forced to fully trust the edibility of the food offered to them, not knowing the ingredients appearing so suddenly through the partitions.

⬆ *WANDBISS*, 2007. Photography: Gianni Plescia. Courtesy of Swiss Institute, NY.

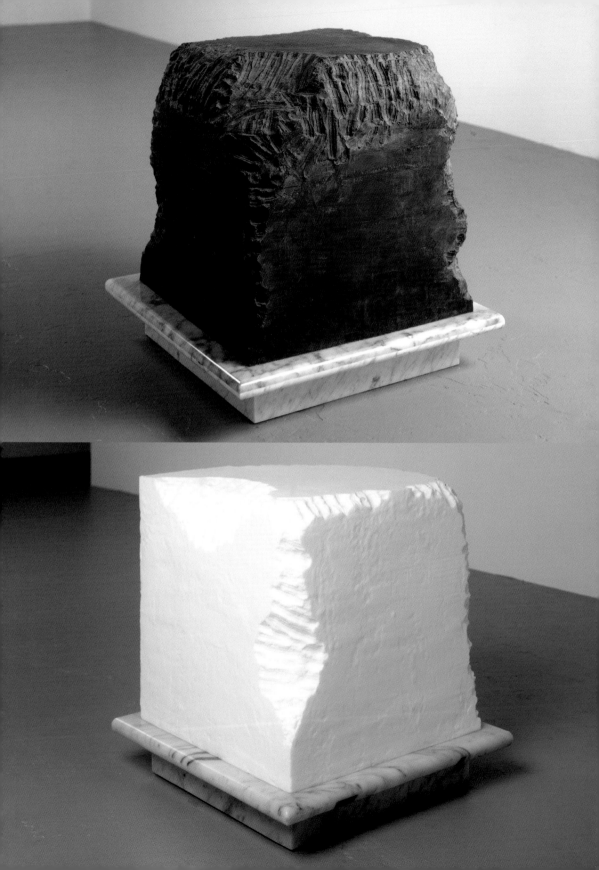

Janine Antoni

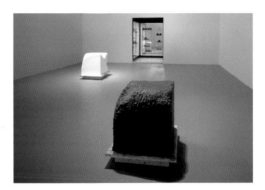

Janine Antoni's 1992 installation of sculptures, *Gnaw*, was conceived through her desire to "do the most traditional thing" she could as an artist—to "carve". In addition to partaking in this most rudimentary approach to sculpture, Antoni desired to depart from the traditional figurative focus of the body, preferring to "talk about the body by the residue it left on the object". To realise this ambition, she decided to use her own body as her tool, to carve with her mouth. She is, she explains, "interested in the bite as a kind of primal urge... because it was both intimate and destructive".[1]

Antoni proceeded to cast two 600lb cubes of chocolate and lard, the reasoning for which was relatively straightforward—"I was interested in how the viewer was overcome with desire for the chocolate, and disgusted by the lard. And then I would turn around and take that very material that was disgusting and make it into lipstick, which we use to make ourselves attractive."[2]

These were then chewed by the artist, and the edible detritus spat out, melted and recast into other objects: specifically, heart-shaped chocolate box packaging in the case of the chocolate, and 150 lipsticks with the lard and pigmented beeswax. The subtle, idiosyncratic differences inherit in the otherwise identikit forms of the chocolate and lard cubes can be seen in details of the indentations: whilst those in the chocolate are starkly visible as bite marks, given the harder substance, those in the lard are accompanied with grooves made by Antoni's nose and chin. The inevitably increasing liquidity of the lard block also meant that it would eventually collapse from the short marble plinth to the floor.

The conceptual theory behind *Gnaw* runs a little deeper though. Laura Heon, in her essay "Janine Antoni's Gnawing Idea", posits that the piece "is as much about art history as it is about desire", located in the gap between the opposing 1960s movements of feminist performance art (as something feminine and physical) and Minimalism (stark, masculine and cerebral) "[adapting] the cubes from the minimalist vocabulary and the gnawing from the lexicon of [the latter]" in to "uneasy confluence".[3]

[1] [2] http://www.moma.org/collection/object.php?object_id=8202.
[3] Heon, Laura, "Janine Antoni's Gnawing Idea", *Gastronomica: The Journal of Critical Food Studies*, Vol. 1, No. 2, Spring 2001, p 5.
↖ *Gnaw* (chocolate cube), 1992, Sandra Gering, New York, 600 lbs of chocolate, gnawed by the artist, 24 x 24 x 24 inches. ↙ *Gnaw* (lard cube), 1992, Sandra Gering, New York, 600 lbs of lard, gnawed by the artist, 24 x 24 x 24 inches. All images courtesy of the artist and Luhring Augustine, New York.

Not an Artichoke,
Nor from Jerusalem

SUMAC MANNAHATTA COCKTAILS
(Our chosen poison)

CANNONBALL ALGAE SALAD
(For the future)

ASIAN SHORE CRAB &
KNIFE-HANDLE TOFFLE
WITH TONG HO
(Flashing blades for the invader)

GINGKO NUTS
(Local to Pangaea)

SHAD ON RYE
(To fair Connecticut's northernmost source,
O'er sand-bars, rapids and falls,
The Shad Spirit holds his onward course)

AUTUMN OLIVE BERRY
ICE CREAM
(To change the tenor of your mood,
we recommend a superfood)

WHORES' EGGS
(Or, gonads of the urchin)

COFFEE
(A brief nod to sobriety)

INVASIVE KNOTWEED SOUP
(Despised things flourish)

EXIT
(Peaceably and without regret)

HAUD NOMINE TANTUM

Marina Zurkow is a Brooklyn-based multidisciplinary artist who builds "environments that are centred on humans and their relationship to animals, plants and the weather", stressing the notion that "nature has long been a stage upon which we project ourselves, making ourselves other". She is part of the faculty of NYU's Interactive Technology Program and her artwork has been exhibited internationally.

Not An Artichoke, Nor From Jerusalem — a dinner event held at The Artist's Institute, New York in 2012 — was a collaborative concept devised by Zurkow, Michael Connor and Alex Freedman. The remit behind the event was to "render the local exotic, and the exotic all too local", an aim realised in the appropriation of ingredients harvested in local waters and their shores, whether native species or inevitable "invaders" — that is to say, that arrived in New York as "hitchhikers… or once-welcomed foreign guests". Thus, guests were served a five-course meal featuring such idiosyncratic delicacies as boiled and fried gingko nuts; smoked shad (a kind of superabundant fish, the Latin name for which, *Sapidissima*, means "very delicious"); "Whore's Eggs" (sea urchin and oysters on beds of tong ho and wild seaweed, respectively); Japanese knotweed soup; marinated cannonball jellyfish; Asian

shore crab with "knife handle toffle"; and pine affogato. The very exoticism of the terminology played a crucial role in the identity of the dinner. "Language frames our experience of food," Zurkow states, "and these names evoke rich and bloody histories that have identified them as food or as pest." The guests at *Not An Artichoke, Nor From Jerusalem* received an elaborately illustrated menu designed by Zurkow, and each course was preceded with an explanatory, if sometimes abstract toast. For example:

Who wants my jellyfish?
I'm not sellyfish!
–A poem by Ogden Nash.
As we won't be able to selly much fish in the future, it's time to get down with our primordial friends as they take over our acid, warming, oceans.
The joy of jellyfish lies in their crunch.
Malaysians call jellyfish 'music to the teeth'.
A toast, to the Rise of Slime, and especially to jellyfish, the true beneficiaries of our great mess.

⟵ Marina Zurkow in collaboration with Michael Connor and Alex Freedman, *Not an Artichoke, Nor From Jerusalem*, menu design. Courtesy Marina Zurkow and bitforms gallery. ⟱ Marina Zurkow in collaboration with Michael Connor and Alex Freedman, *Not an Artichoke, Nor From Jerusalem*, 2012. Photography: M Cianfrani.

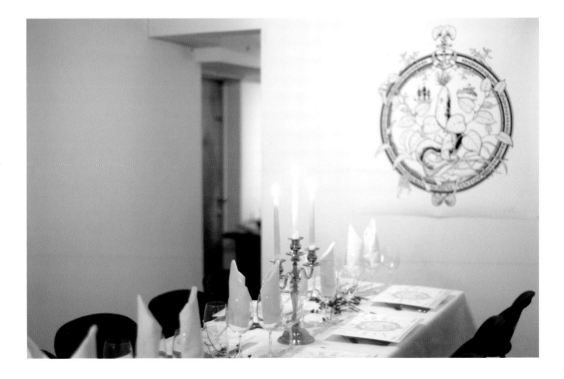

Joyce Wieland

Born in 1931, Canadian experimental filmmaker Joyce Wieland was a pioneer for women in an industry that had been male-dominated until the latter half of the twentieth century. In 1960, Wieland was the first woman to feature work at the Isaacs Gallery in Toronto, and was the first living woman to exhibit a solo show at the National Gallery of Canada in 1971. She was married to fellow filmmaker Michael Snow from 1956–1970, and in 1982 was made an Officer of the Order of Canada, before passing away as a result of Alzheimer's disease in 1998.

Wieland's work remains highly regarded in the realm of experimental filmmaking. She favoured an avant-garde style, often employing a manipulation of the filmstrip, as demonstrated in one of her most famous works, 1969's *Catfood*. In the film (a short starring her pet cat Dwight), a cat is shown devouring fish from a variety of angles. The stream of fish is non-stop, and Dwight does not stop eating for the duration of the film's 13 minutes. Wieland's manipulation of the time-frame is key, as she uses several jump cuts and changes the angle of the shots at a rapid pace. In one instance, we see the cat from a low angle eating half a fish, and in the next, the shot is from above, and the fish whole. This visual manipulation is confusing; the viewer can't be sure what the order of the film's events truly is; we can't even be sure that Dwight is the only cat featured. Importantly, Wieland lingers several shots on the fish as they are eaten, showing their open eyes and establishing them as a kind of victim; arguably the most striking shot appears 12 minutes in, when the silhouette of the cat is shown hovering over a fish, the only visible part of which is a pair of open, lifeless eyes.

↑ *Catfood*, 1969, film still. Courtesy Canadian Filmmakers Distribution Centre.

Yangjiang/ Grizedale

Chinese artists Zheng Guogu, Chen Zaiyan and Sun Qinglin originally founded the Yangjiang Group in 2002 in Yangjiang, a large new city characteristic of China's increasingly widespread urbanisation and globalisation. The group's collective work reappropriates traditional Chinese art forms within contemporary practices as a commentary upon the rapid cultural transformation of contemporary China—for the Yangjiang Group, calligraphy in particular expresses the fluidity and unpredictability of modern life. The collective construct semi-public spaces within which they perform daily actions, such as socialising, organising, eating, drinking, bartering, and playing games as part of their artistic activities in an attempt to redress ancient Chinese philosophy within an active context.

After Dinner Shu Fa at Cricket Pavilion, 2010–2012, was a collaborative project between the Yangjiang Group and two UK-based arts organisations: Grizedale Arts, based in the Lake District, and Eastside Projects, an artist-run space in Birmingham. The installation took the form of a ten-metre square and four-metre high Chinese tea pavilion made from wood and plastic. Here the artists enjoyed a banquet style meal and then made *shu-fa*—the art of calligraphy—from the leftovers in front of an audience, arranging corn, rice, shrimp heads and lotus roots into calligraphic sequences. Photographs of the work were then displayed in the gallery. The construction was later transported to Grizedale Arts, where it operated as a prototype cricket pavilion-cum-tea pavilion-cum-art space for their local village. The Yangjiang Group and their pavilion also featured at Frieze London in 2012 as part of a programme of food-related performance, discussion, representation and retail entitled the *Colosseum of the Consumed*, hosted by Grizedale Arts and the Frieze Foundation.

⬆ Zheng Guogu, Yangjiang Group, at the *Colosseum of the Consumed* by Grizedale Arts and the Yangjiang Group, Frieze Projects 2012. Courtesy of Maria Benjamin and Grizedale Arts.

Vivian
Ostrovsky

Vivian Ostrovsky's 1988 film *EAT* is—according to the artist herself—"a playful collage of humans' and animals' table manners as they gulp down breakfasts, lunches and dinners in a variety of situations",[1] calling into question the truism that "animals 'feed' and humans 'eat'".[2] "The first thing I learned" Ostrovsky recalled, "was that people hate being filmed whilst eating. Animals don't seem to mind as much."[3] Aiming to be as unobtrusive as possible, Ostrovsky filmed people at large gatherings using a small Super 8 camera while visiting open-air festivals, agricultural salons, restaurants with terraces and, of course, a few zoos.

Ostrovsky gathered the documentary material for *EAT* whilst travelling through Paris, Berlin, Barcelona and Vaison-la-Romaine in Provence. Born in New York before growing up in Rio and studying in France, Ostrovsky is habitually nomadic, touring Europe during the early 1970s promoting, distributing and exhibiting films by women artists through festivals and symposiums. She began making her own work in the 1980s and became known for her mosaic-like documentary films that incorporate found footage into her own. Mostly shot in Super 8 and blown up to 16mm film, Ostrovsky's films are voyeuristic diaries and travelogues. Through a process of collating, collage and editing, Ostrovsky documents the everyday with humour and whimsy.

Several of Ostrovsky's films deal with food and eating through travel. A personal film diary of many family visits to Moscow, *Nikita Kino*, 2002, is an album of picnics, markets and days out with food. Taking the role of observer in ***(Trois Etoiles)*, 1987, Ostrovsky follows two Californians as they eat their way through a tour of France, testing the Michelin

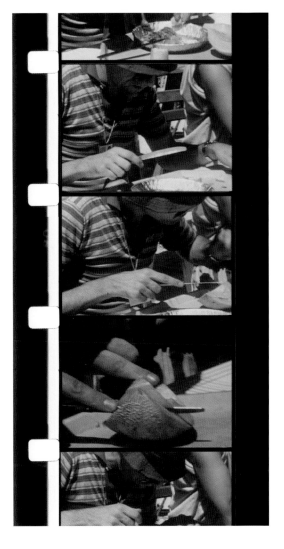

guide's recommendations for three star restaurants. "I love observing kitchen preparations", Ostrovsky says of her fascination with food, "people consumed by what they feed on": an astute observation in an era of food blogs, online recipe sharing, touring TV chefs and televised cooking competitions.

A dedicated cinephile, Ostrovsky's recommended menu of food films would include Syberberg's *Ludwig's Cook*, a biography of Ludwig II of Bavaria seen through the eyes of his cook, Chaplin's *Modern Times* with its eating machine invention, and Thomas Vinterberg's *Festen*, the tense story of a family gathering.[4]

① Author's interview with artist, July 2014. ② cmzimmerman. blogspot.co.uk. ③ ④ Author's interview with artist, July 2014. ⬅⬇ *EAT*, 1988, film stills. Courtesy the artist.

Jan Švankmajer

Hugely lauded for his idiosyncratic and often nightmarish use of stop-motion animation, Czech surrealist filmmaker and artist Jan Švankmajer is well known for films such as *Alice, Faust, Little Otik* and *Lunacy*, drawing extensively on classic literature in his blackly comic and macabre work.

The two late-twentieth century shorts *Meat Love*, 1988 and *Food*, 1992, exemplify Švankmajer's ongoing interest in the fetishist aspects of eating, notions derived in part from the artist's childhood dietary problems and the subsequent trauma afforded by the tactics of his parents and physicians to counteract these: for Švankmajer, "eating is a symbol of human aggressiveness".[1]

The single-minute-long *Meat Love*—created for use as a commercial within *Little Otik*—is an unexpectedly poignant micro-fiction portraying the courtship, consummation and swift 'death' of a couple, in this case a pair of freshly sliced beefsteaks. The short is both irreverently witty and self-consciously tragic—its razor edge afforded by the "unignorable fact that the slices of meat were once part of a living creature with its own range of feelings"—and significantly more appetising than *Food*.[2]

Food comprises three separate meals: "Breakfast", "Lunch" and "Dinner". The former is set in a bleakly decrepit cafe, in which customers queue patiently for a seat at a table for two. The notion of 'self-service' is redefined by the fact that a meal of bread and sausage is

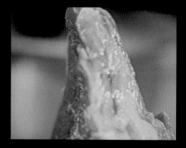

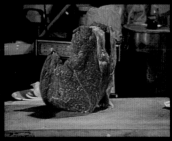

attained by physically wrenching it from the body of the last diner, by way of a chest-installed dumb waiter and various other abusive playground interactions.

"Lunch" sees two socially disconnected diners —one a smart-looking businessman, the other a somewhat dishevelled down-and-out type—fail to grasp a waiter's attention. Lacking conventional food, they begin to eat everything in front of them—the vagabond copying the actions of the businessman— from the flowers on the table, through crockery, furniture, clothes and, finally, the metal utensils.

"Dinner" is the most grotesque chapter of the set. A rotund man sits at a packed table in a classically Michelin-style restaurant. After adding myriad spices and condiments to his plate, the diner begins to secure a fork to his wooden left hand—by way of a hammer and nails—before eating what we assume was his original appendage. We then flit between numerous humorously visceral scenes: an athlete consuming his own leg; a woman her breasts; and, lastly, a man moves to eat his genitals, before urging the camera away.

① "Food," in Jan Švankmajer: The Complete Short Films (DVD booklet), BFI: London, 2007, p. 39 ② "Meat Love," in Jan Švankmajer: The Complete Short Films, p 34 ← ↓ *Meat Love*, 1988, film stills. Copyright spolecost pro filmovou tvorbu, s.r.o. Images courtesy Koninck International, Nomad Films and MTV (USA), and Jan Švankmajer.

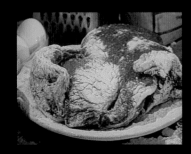

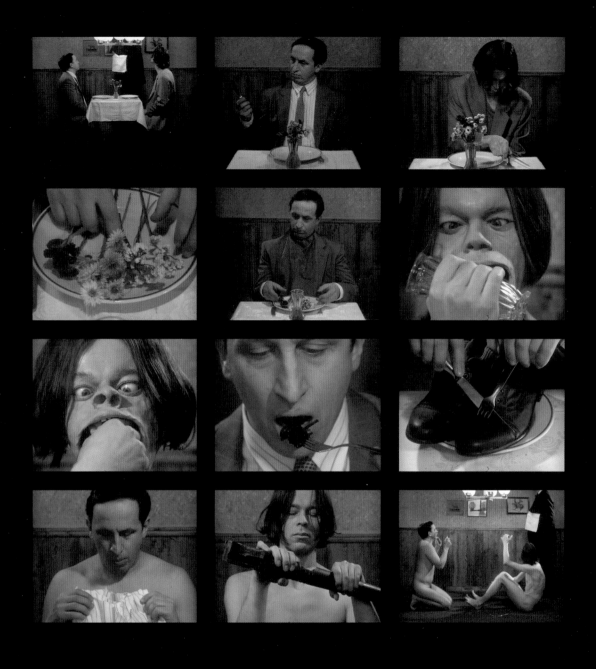

⬆ ➡ *Food*, 1992, film stills. Copyright spolecost pro
filmovou tvorbu, s.r.o. Images courtesy Channel 4, Koninck
International, Heart of Europe, and Jan Švankmajer.

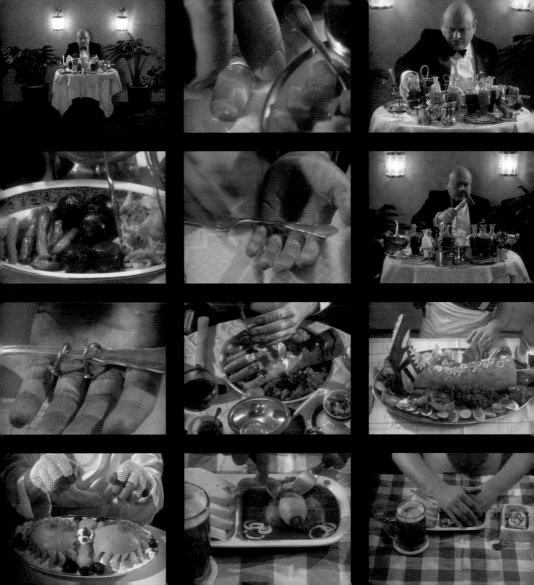

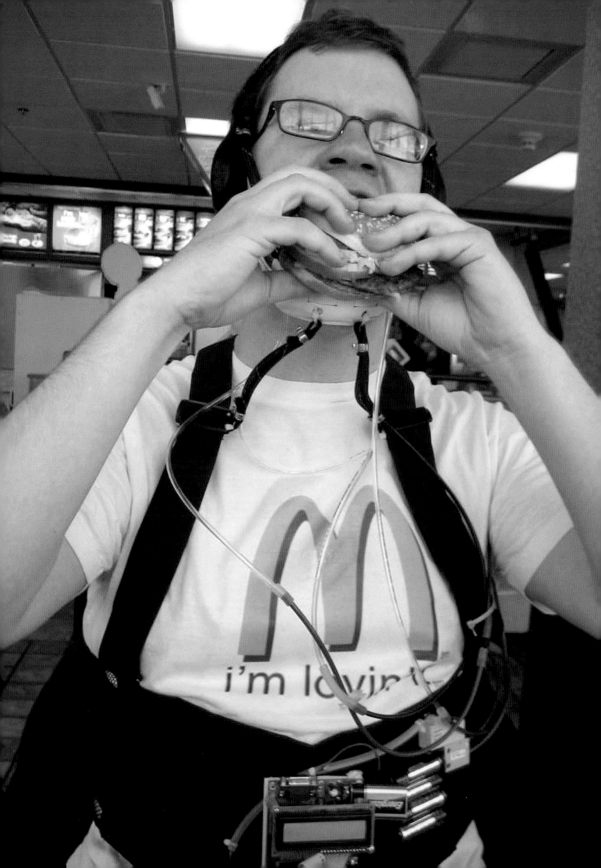

SWAMP

SWAMP (Studies of Work Atmosphere and Mass Production) is a multimedia organisation founded in 1999 by the artists Douglas Easterly and Matt Kenyon, though it is now operated as a solo endeavour by Kenyon, in addition to his work as an Associate Professor within the School of Art and Design at the University of Michigan.

Since its inception, SWAMP has utilised a wide range of media—from custom software and electronics, through mechanical devices and living organisms—to produce works that focus on cortical themes, "addressing the effects of global corporate operations, mass media and communication, military-industrial complexes, and general meditations of the liminal area between life and artificial life".[1]

Coke is it is an artwork comprising a robotic hex-crawler, outfitted with a CMUcam, named C3. The integrated camera allows the robot to locate spilt puddles of Coca Cola, which it sucks up via an electrical pump before spraying the liquid across itself. The acidic compounds in the Coke then corrode through the robots skin before reaching and breaking the enclosed circuitry; a process of 'search and consume' that sees the robot eventually kill itself—a salient comment on the way that companies such as Coca Cola "deploy marketing strategies that infuse culture with a sense of well-being and elevated self-worth, contradicting the actual benefits of the consumable product", according to SWAMP.[2]

Meat Helmet presents a similarly irreverent take on mass consumption, a "scrutinising look at the fast food chains absurd attempt to market to the health conscious", and an art vehicle designed to expose the user to the pains of enjoying the 'luxury' of such food. The helmet is controlled by a computer in the belt, which forces the wearer to eat at specified intervals via integrated, pneumatically activated 'air muscles'. A number of calories is punched in to the attached keypad (a Big Mac is 560 calories, for instance); the helmet then calculates the amount of chewing time it would take to burn these off—chewing uses around 70 calories per hour, so eight hours in this case—and activates the inevitably protracted programme of forced mastication.

(1) http://www.swamp.nu/about/ (2) http://www.swamp.nu/projects/coke-is-it/. (←) *Meat Helmet*, custom electronics. Courtesy the artist. (↑) *Coke is it*, umbrella, Coca Cola. Courtesy the artist.

Julio Cesar Morales

Julio Cesar Morales, who was born in Tijuana, Mexico in 1966, and is now based in Phoenix, Arizona, operates under the guises of artist, curator and educator, exploring issues of "migration, underground economies, and labour on personal and global scales".[1]

His 2008 video-based project *Interrupted Passage* was a response to requests for a site-specific work in Sonoma Country, California, specifically focusing on the transfer of Alta California from Mexico to the United States in the mid-1800s. The project revisits and examines Mexican General Mariano Guadalupe Vallejo's last eight hours in power and his subsequent arrest.

The dual-channel video—both channels working to Fernando Corona's soundtrack, which alternates between the electronic and the traditionally symphonic —comprises two distinct scenes revolving around food preparation and the meal as important cultural-historical narrative devices. One portays a re-enactment of the events of 14 June 1846: 33 armed men—the so-called "Bear Flag Revolters" (played here by a number of Morales' artist friends)—arrive at Vallejo's home demanding the surrender of lands to the US, but are taken aback by the General's response to this act of blatant aggression. Vallejo invites the intruders into his home as guests, then prepares an all day feast consisting of homemade wines, Aguardiente, appetisers, entrees, and dessert for them. The emphasis on food in Morales' recreation of events "connects this historic event to the current proliferation of food-based culture and social interaction in California".[2]

The second video is both simpler and more abstract, displaying in visceral detail the preparation of a huge beef carcass, which is stripped of fat, bound with rope and roasted over an open fire, as well as the dicing of fennel bulbs and the slow stirring of a large stew.

"I was", Morales states, "trying to come to something in between all these different variations. History always has multiple points of view. How do you negotiate these points of view? How do you go further than what's handed to you? It's about questioning history, but it's also about making it more accessible.... I just want to take a little bit of history back."[3]

[1] http://gallerywendinorris.com/docs/Julio%20Cesar_Morales_essay.htm. [2] http://www.kadist.org. [3] http://www.sfweekly.com/2008-10-08/culture/re-enacting-the-birth-of-california/ [→] *Interrupted Passage*, 2008, two HD videos (8.5 minutes each). Courtesy of the artist and Gallery Wendi Norris, San Francisco.

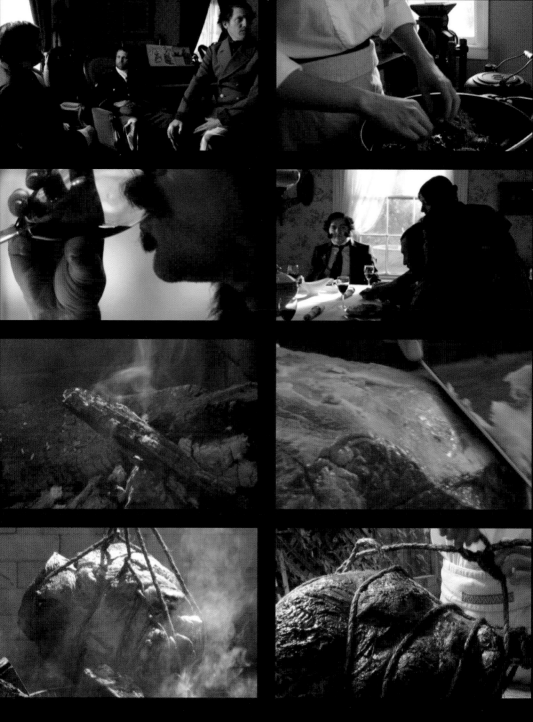

Peter Greenaway

Peter Greenaway began his artistic career in London, where he trained as a painter for four years. He went on to exhibit in galleries around Europe, such as the Palazzo Fortuny in Venice, the Joan Miro Gallery in Barcelona, the Boymans van Beuningen Museum in Rotterdam and the Louvre in Paris. Greenaway has also made 12 feature films, 50 short films and documentaries, and has been nominated for awards in film festivals such as Cannes, Venice and Berlin. His first feature film, *The Draughtsman's Contract*, 1982, was well received and followed by equally popular films such as *The Cook, the Thief, his Wife & her Lover*, and *The Pillow-book*.

Peter Greenaway's interest in Italy's rich Renaissance art history inspired his 2008 series *Ten Classic Paintings Revisited*, in which modern and classical art were combined to create a unique vision. Greenaway's passion for film infiltrates the various works through the use of sounds, light manipulation and theatrical illusion.

Peter Greenaway's take on *The Last Supper* was exhibited in a model of the dome of Refectory of Santa Maria Delle Grazie, where the original work exists. An exact digital replica of the original fresco was used by Greenaway to give the audience an authentic view of the work. With the purpose of provoking viewers to look at *The Last Supper* with new perspectives, Greenaway translates the classical piece into an audio-visual, multimedia experience, using projections of images, light and soundscapes which spectators could navigate through and truly engage with.

↑ *The Last Supper*, 2008, multimedia. Copyright Luciano Romano/ Change Performing Arts. Courtesy the artist.

Mella
Jaarsma

Though she grew up in the Netherlands and retains Dutch citizenship, artist Mella Jaarsma maintains her residence in Yogyakarta, Indonesia, where she has lived for over 30 years. Together with her husband, fellow artist Nindityo Adipunomo (with whom she was jointly awarded the John D Rockefeller Award in New York in 2006), Jaarsma runs the Cemeti Art House, a gallery that specialises in the promotion of young artists.

I Eat You Eat Me is typical of Jaarsma's practice — engaged in discussions around the relationship between people and social environment. Originally created in 2002 in Bangkok's Eat Me restaurant, the interactive installation, in its variable incarnations — it has been duplicated in locations as diverse as Jakarta, Sweden and Chicago — invites participants to a unique experiential dinner party. Participants are paired and sit facing one another at one of Jaarsma's specially designed dinner tables, which, instead of standing on the floor independently, levitate between the participants, attached to them by a wearable bib slipped over the head of each diner.

Perhaps the element of the meal most obtrusive to the participants' successful ingestion is that they are denied the ability to feed themselves, instead depending on their dining partner to aid them in everything from ordering to bringing spoonfuls of food to their open mouths.

Giving up direct, physical control over a meal in this way, one submits oneself to the power of another, even perhaps, to the humiliation of being fed again like a child. In *I Eat You Eat Me*, this often results in the formation of intimacy and innate trust between the couples, those who flip the rituals of eating and symbolically give up inherent control in the sustaining of their own life for the course of the meal.

↑ *I Eat You Eat Me*, 2000–2012, aluminium, leather, food. Courtesy of the artist.

Kultivator

Kultivator is an experimental amalgam of organic farming and visual art practice situated in the rural village of Dyestad, on the island Öland, off the southeast coast of Sweden. Founded in 2005 by artists Mathieu Vrijman, Malin Lindmark Vrijman and Marlene Lindmark, and farmers Henric Stigeborn and Maria Lindmark, Kultivator is now an open group, with members varying from project to project. The site comprises a residency, exhibition space and a dairy farm with cows, chickens, ducks, sheep and horses. Since its initiation in 2005, approximately 80 artists, researchers and farmers have visited and worked on the premises.

By installing itself within previously abandoned farm facilities and being located close to active agricultural communities, the project provides a meeting and working space that draws attention to the parallels between provision production and art practice, between "concrete and abstract processes for survival". Its residents hold projects, exhibitions and workshops that explores possible alternative narratives within the dual notions art and farming, involving both direct members and/or invited guests and the public.

The group's 2011 happening *Lunch With Cows*, a continuation of the earlier *Dinner With Cows* held at the Kultivator's Swedish hub in 2006, was held at the Tammenpää milk farm, on the west coast of Finland. Comprising an alfresco meal, the table populated by people on one side, cows on the other; the concept is seemingly quirky but exists as a conduit for nuanced discussion around socio-historical aspects of agricultural life and issues of sustainability. The group's manifesto for the project lays clear the aims both simply and, through a small amount of mistranslation, poetically:

Since almost ten thousand years now, we live very close to each other, and have indeed affected each other's lives and beings a great deal. Our relation has been practical and very close physical, but we have not yet really grown into exchanging a lot of thoughts, or even trying to meet at an intellectual level. This informal lunch meeting intends to be a small start of a more mature and interesting way of being together. We have no prepared speakers, no translators or list of topics that must be discussed, but! Questions about our future relation, and sustainable survival may come up!

← *Lunch With Cows*, 2011. Courtesy the artists.

Leftovers

IV

Darren Bader

Darren Bader is a conceptual artist based in New York. After studying film production and art history at New York University, he went on to exhibit his work at institutions such as MoMA PS1, New York and 1857, Oslo. He is also a writer and has published several books.

Much of Bader's work revolves around sculpture and the readymade, and tends to focus on the quiet relationships between seemingly unrelated, juxtaposed objects, as exemplified in his 2013 exhibition Heaven and Earth, at Blum & Poe, Los Angeles. These connections blur the distinction between rational and subjective criteria, appearing on some occasions disarmingly incongruous, but they provoke viewers to consider how, as *New York Times* writer Roberta Smith noted: "Everything is connected, and nothing is".[1] Bader has explained in the past that his art is about "metaphysics and the world we live in"; despite its subversively surreal qualities, his work possesses a strong philosophical leaning, posing questions on the existence, properties and sociocultural purpose of his chosen subjects.[2]

This notion of juxtaposition is conspicuous in many of Bader's food-based works, whether playing on notions of the ludicrous or wistful. One such piece, *chicken burrito, beef burrito* is a melancholy construction, comprising two burritos displayed on a windowsill. Another two, both titled *sandwiches*—from the 2012 exhibition Where is a Bicycle's Vagina (and Other Enquiries), or Around the Samovar at 1857—are more jovial, if no less perplexing. They consist respectively of a football table covered in shrimp and a raw salmon fillet, smeared in acne cream, tucked between two Paul Newman DVDs. The artist here plays with the conventions of sculpture, pushing spectators to consider what they believe the boundaries of art truly are—a familiar function of the readymade. The work's polemical nature derives from its simplicity as a piece of art; Bader does not ardently defend the unconventional nature of his practice, but instead tries to explain what it means to him personally: "I might hate my work too if it wasn't mine; I very rarely love it. But coming from the purview I come from… I only know how to explore the world and the word/tissue/pathos/ethos of 'art' in the way that feels germane to me."[3]

(1) http://aspenartmuseum.org/event/darren-bader/ (2)(3) http://moussemagazine.it/articolo.mm?id=897 (→) *antipodes: Parmigiano-Reggiano* (detail), 2013. Copyright the artist, courtesy Franco Noero, Turin; Andrew Kreps Gallery, New York; and Sadie Coles HQ, London.

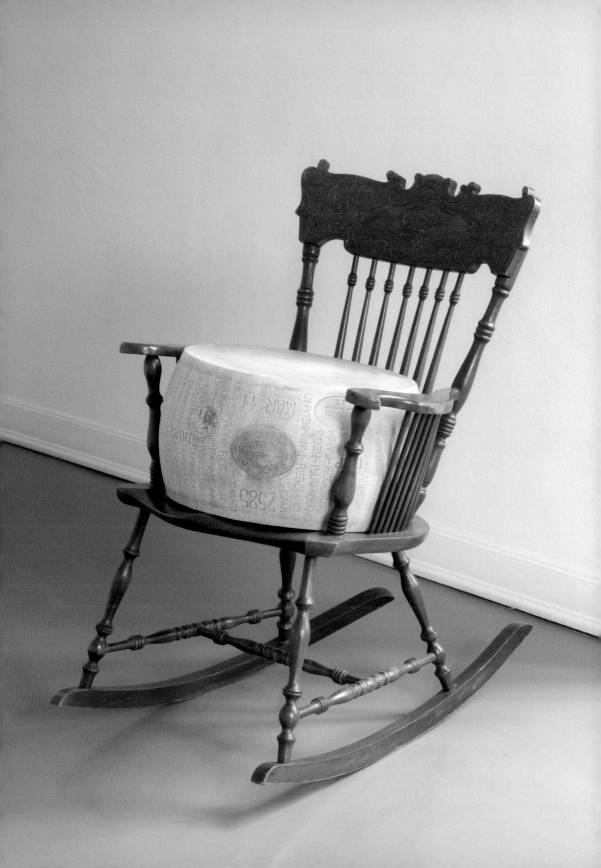

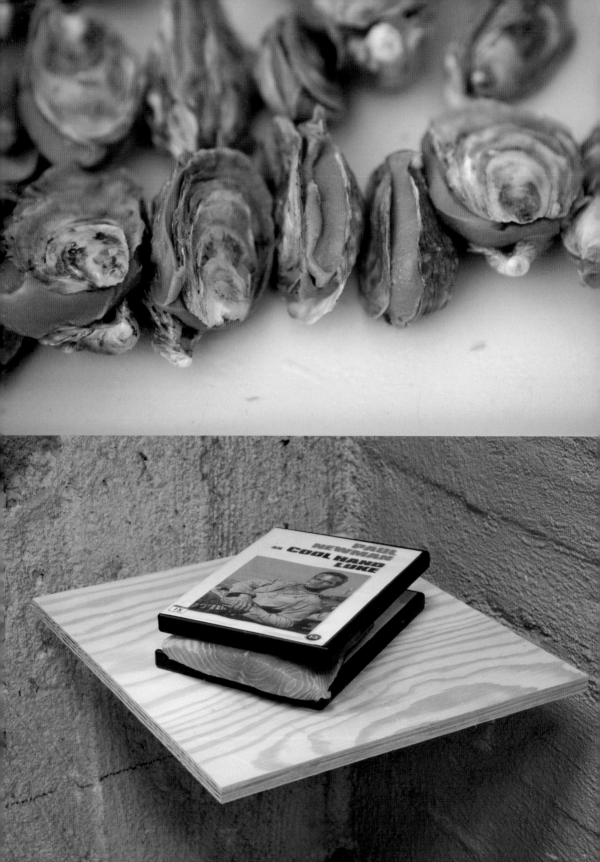

↑ *Oysters with/and Peanut Butter*, 2013. Copyright the artist,
courtesy Andrew Kreps Gallery, New York; Blum & Poe, Los
Angeles; and Sadie Coles HQ, London. ↑ *sandwiches; salmon,
acne cream, DVDs and DVD Covers* (detail), 2012. Copyright the
artist, courtesy Andrew Kreps Gallery, New York and Sadie Coles
HQ, London. ← *chicken burrito, beef burrito*, 2012. Copyright
the artist, courtesy Andrew Kreps Gallery, New York and Sadie
Coles HQ, London. ↑ *sandwiches; foosball table, baguette, shrimp*
(detail), 2012. Copyright the artist, courtesy Andrew Kreps
Gallery, New York and Sadie Coles HQ, London.

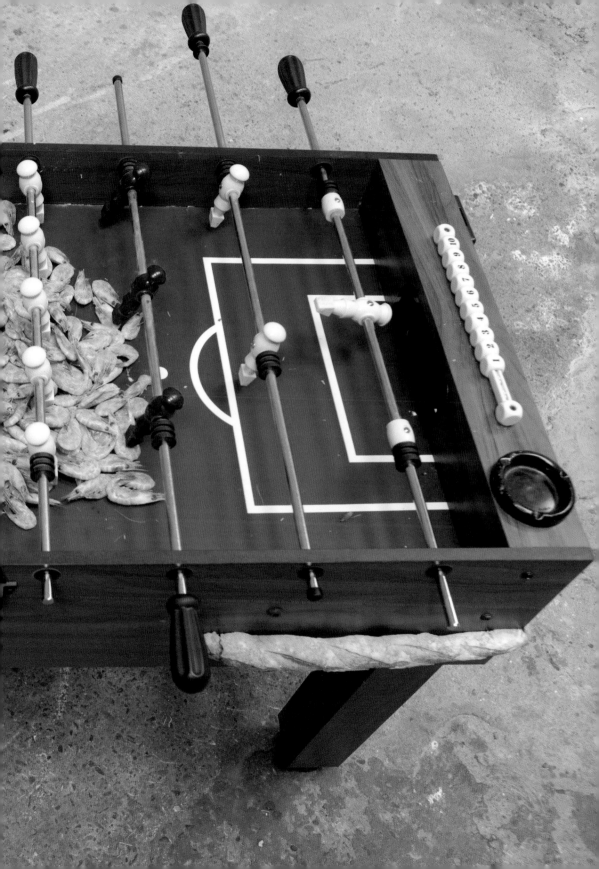

Keiji
Takeuchi

Keiji Takeuchi is a freelance designer based in Milan. He left Japan for New Zealand at the age of 15 where he joined the UNITEC school of Art in Auckland. In his final year of product design he won the New Zealand's national design award, among several others. Since 2005 he has been a designer at Naoto Fukasawa Design Ltd, where he works under renowned designer, Naoto Fukasawa.

Tackeuchi's design projects are all consistent in their originality, but *Juice Skin*—an endeavour that saw him experiment with consumables and their packaging—is particularly ingenious. For this project, Tackeuchi used various fruit skins to create biodegradable fruit juice cartons: a tall, thin, bright yellow carton, complete with inimitable banana fruit sticker and the tip of a banana skin folded neatly over the edge, a squat, hairy, brown kiwi-skin carton, and a miniature red pock-skinned and juicy looking strawberry carton sit in a collection of superbly designed boxes, in equal measures recognisable and surprising in their colour and textures.

The intention is interpretable. *Juice Skin* performs powerfully as a testimony to modern day wastefulness, and impeccably as a design-conscious creative venture. Either way, Takeuchi's cartons are a joyful and impressive sight.

⟵ ↑ *Juice Skin*, 2004, TAKEO PAPER SHOW, 2004, "HAPTIC". Courtesy the artist.

Klaus Pichler

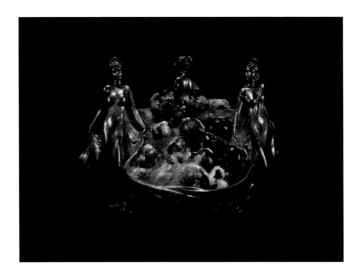

Klaus Pichler is an Austrian photographer whose work explores the myriad hidden aspects of everyday life and the idiosyncratic workings of different social groups. The remit behind his photographic project *One Third* draws on a desire to expose the contemporary proliferation of global food waste (particularly that generated by the industrialised nations of the northern hemisphere): according to UN reports, a staggering one third of the globe's food supplies go uneaten, a statistic made more incomprehensible when juxtaposed with the fact that 925 million people are threatened with starvation on a daily basis.

Pichler's highly stylised, Baroque-leaning still life images of degrading foodstuffs — from mould-embellished cup cakes, to putrefying bowls of fruit, by way of an unctuously leaking octopus carcass and withering cheese, set against a velvety black backdrop — are accompanied by specific information regarding production locales, cultivation methods, commercial worth, transport modes and distances, harvest times, carbon footprints, and water requirements, affording a subtly comprehensive critique to the issues embedded within the striking aesthetics. The photographs run the gamut from luridly beautiful to genuinely stomach-turning — see the aforementioned octopus — but all are effectively impactful in their construction.

↑→→→ *One Third* (*Cherries; Strawberries; Octopus; Cheese*), 2011–2012. Courtesy Klaus Pichler / AnzenbergerGallery, Vienna. www.anzenbergergallery.com.

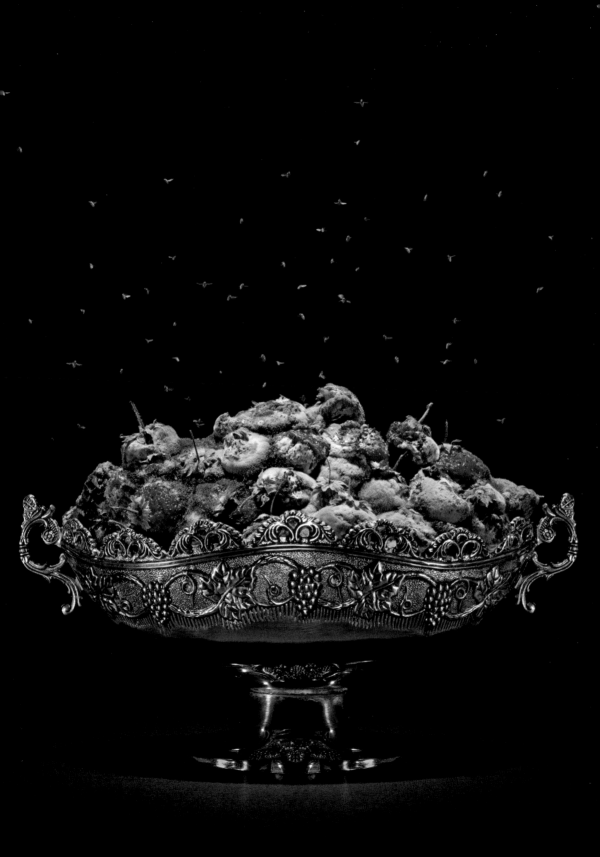

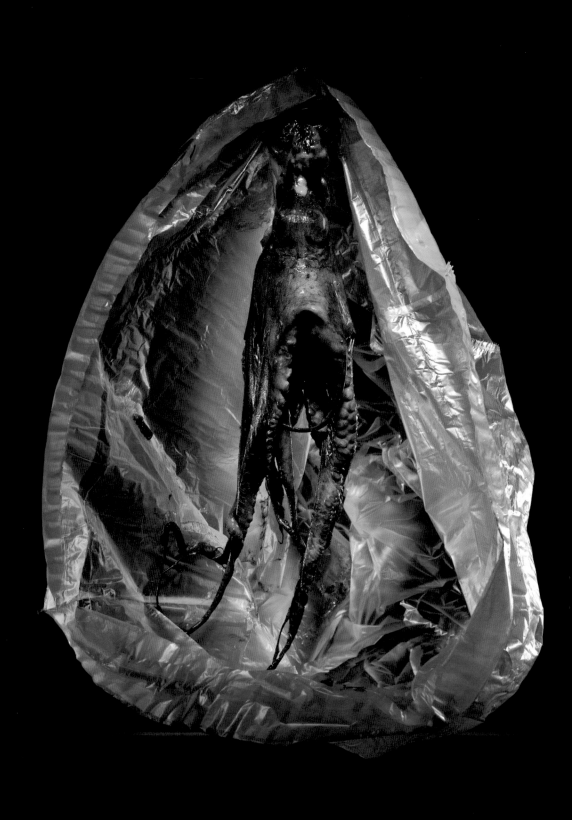

Uli Westphal

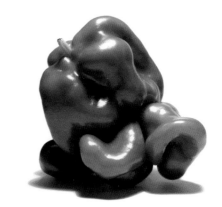

The Berlin-based German artist Uli Westphal conceptualises much of his artwork around questions on the philosophy of biology; particularly "how nature is perceived, depicted and understood" in the contexts of culture and science. Westphal is fascinated by "human conceptions of nature", which, as he shows in his *Mutato Project*, are highly normalised through external sources in society. The project, initiated in 2006, explores the stigmatisation of perceived abnormality in the consumption of produce. Commenting on the 1958 "uniform standardisation parameters" set on 26 different fruits and vegetables, Westphal explores the sharp drop in agricultural diversity in European supermarkets by photographing fruits and vegetables that fall outside these parameters. Though many of these 'abnormal' examples have nothing inherently wrong with them and would taste the same as 'normal' ones, they are discarded on the grounds of their supposedly unacceptable aesthetics. In reality, Westphal says, "the complete absence of botanical anomalies in our supermarkets has caused us to regard the consistency of produce presented there as natural. Produce has become a highly designed, monotonous product.... We have forgotten, and in many cases never experienced, the way fruits, roots and vegetables can actually look (and taste)."[1]

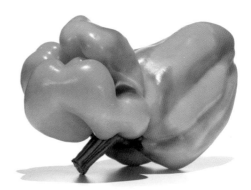

Though the project is aesthetically simple—the fruit and vegetable subjects are photographed against a stark, blank white background—Westphal conspicuously engages with the process and conceptual philosophy of how we actually define and grade produce; as a question saliently posed by Edible Geography, "What do the standards we consciously or unconsciously impose on produce tell us about ourselves, particularly given the fact that today's fruit and vegetables are a human-designed artefact, the result of centuries of domestication and breeding?"[2]

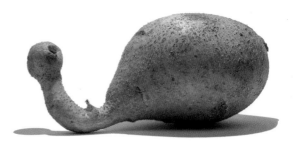

(1) http://uliwestphal.de/mutatoes.html. (2) http://www.ediblegeography.com/the-mutato-archive/. (→) *Mutatoes*, 2006–present, photographs. Copyright and courtesy the artist.

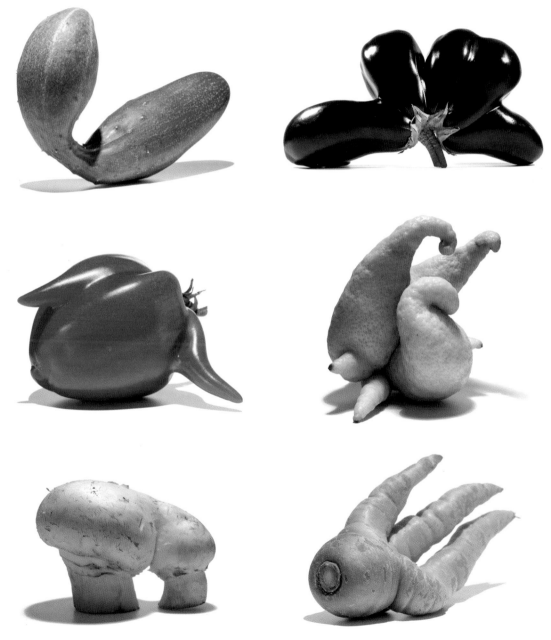

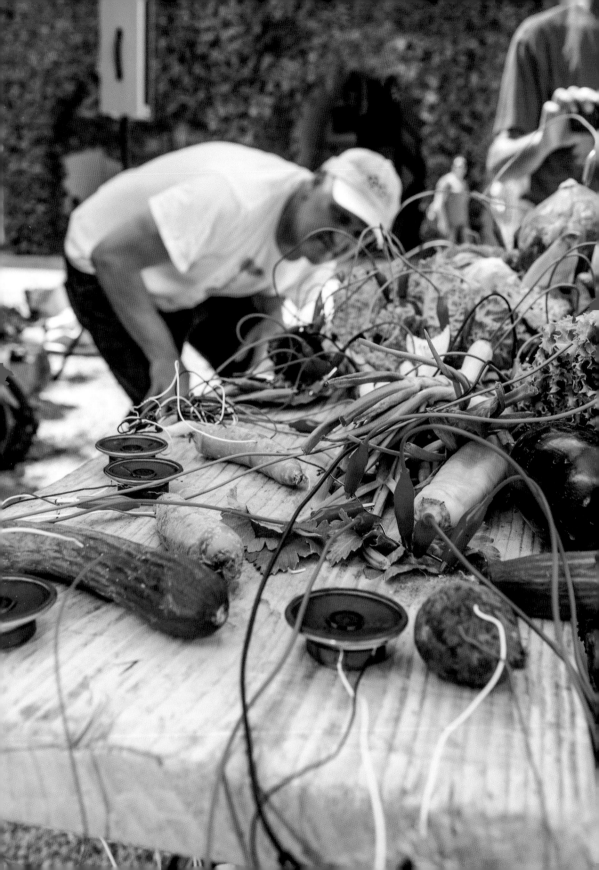

Karl
Heinz Jeron

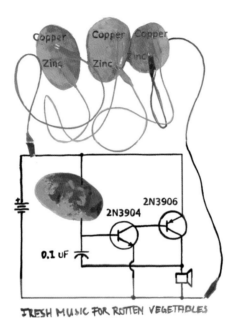

Fresh Music for Rotten Vegetables, by Berlin based artist Karl Heinz Jeron, is a technical participatory installation that uses waste food to raise awareness of society's lackadaisical attitude to alternative energy sources and the ease with which we wastefully discard useful materials. In this homage to punk band Dead Kennedy's 1980 album *Fresh Fruit for the Rotting Vegetables* (in which the band criticise aspects of social inequality) participants who were asked to bring along overripe and soon-to-be disposed of fruits and vegetables, see their would-be waste wired up and used as natural batteries to power a set of speakers and an improvised piece of music. In Jeron's aleatory music (a thread of musical composition in which some element is left to chance) the sound, its quality and volume are all dependent on the state of the collected vegetables, from which the current is derived.

The artwork has received a lot of attention and credit for its unique means of tackling issues of energy and waste, and Jeron—who has exhibited widely in galleries from MoMA in San Francisco to the Berlinischen Galerie in Berlin—has garnered much praise for this piece as a part of a catalogue of work that explores the everyday in relation to larger social issues.

← *Fresh Music for Rotting Vegetables* performance at Festival of Regions, 2012. Licensed under Creative Commons license by-nc-sa 3.0. Courtesy the artist. ↑ *Fresh Music for Rotting Vegetables*, circuit. Licensed under Creative Commons license by-nc-sa 3.0. Courtesy the artist.

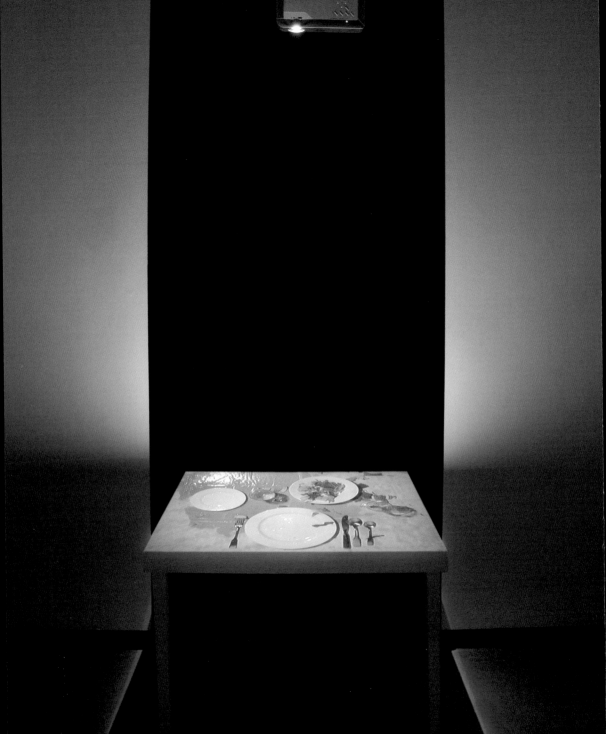

Michael Snow

The experimental filmmaker Michael Snow was born in Toronto in 1929 and is one of Canada's most celebrated living artists. His wide-ranging practice "comprises a thorough investigation into the nature of perception", and utilises disciplines as disparate as film and video, sculpture, painting, writing, photography and music.[1] An immersion in film—notably through alliances made with Jonas Mekas' Filmmakers' Cinematheque after moving to New York in 1961—would result in Snow's most influential work, 1967's *Wavelength*: one of "the most studied and admired works of structuralist filmmaking" and which "notoriously" included a fixed-frame, 45-minute camera zoom.[2]

Snow's 1976 film, *Breakfast (Table Top Dolly)*, is a single shot, 15-minute piece that serves as a "grand metaphor for indigestion".[3] In a single shot, the camera, protected behind a plexiglass screen, moves slowly at and through a breakfast still life, pushing the objects along the tabletop until they tip, fall or smash against the wall. Writer William C Wees states in his book *Light Moving Through Time: Studies in the Visual Aesthetics of Avant-Garde Film* that "Snow's use of the dolly shot in *Breakfast (Table Top Dolly)* vividly—and comically—emphasises the physical effects of the camera's forward movement, in contrast to the purely optical effects of the zoom in *Wavelength*,"[4] an appropriate analysis given the filmmaker's own desire "to make physical things so that the experience is a real experience and not just conceptual".[5]

The serving of food becomes a metaphor for the structure of cinema in *Serve, Deserve*, 2009. Alternatively titled *There you go!, Waiter!*, or *Where's the Bread?* the film installation features a tabletop screen onto which food is projected: a visual meal repeatedly served by the looped 13 minutes of silent colour film. In a painterly fashion, water, salad, wine, noodles and tomato sauce colours the table surface, is rewound, removed and then reapplied. The image's journey to the screen becomes analogous to that taken between the table and the kitchen in a restaurant, yet as a moving picture it is always returned, and served again.

(1) (2) http://eai.org/artistBio.htm?id=8368. (3) Deke Dusinberre, http://sprocketsociety.org/pdf/Wavelength-program-notes-NWFF-Feb-2011.pdf. (4) Wees, William C, "Notes", No 20, *Light Moving in Time: Studies in the Visual Aesthetics of Avant-Garde Film*, Berkeley: University of California Press, 1992, p 176 (approx). (5) http://sprocketsociety.org/pdf/Wavelength-program-notes-NWFF-Feb-2011.pdf. (←) *Serve, Deserve (or Setting, Unsettling)*, 2009, video projection on a table, video loop duration 13 minutes 30 seconds, table surface 86 x 63 cm. Courtesy the artist. (↑) *Breakfast (Table Top Dolly)*, 1972–1976, 16mm film, colour, sound, 15 minutes. Courtesy the artist.

Paul Griffiths &
Cesare Pietroiusti

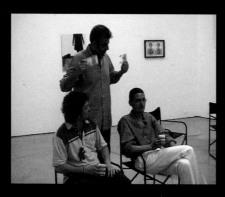

"A public auction is held. Participants make offers corresponding to the sum of two banknotes in euros. The successful bidder gives the two banknotes to the artists who eat them publicly and promise that, once evacuated, they will be returned to the bidder with a certificate."[1]

Such was the synopsis of Cesare Pietroiusti's 2007 piece *Eating Money—An Auction*, performed in collaboration with Paul Griffiths. Italian artist Pietroiusti's interests revolve around the conflicting occurrences that we encounter in our everyday lives, occurrences he explores with audience participation. His performance works err towards the humorous, even the absurd while revealing more serious subtexts. *Eating Money* comprised a mock auction in which audience participants made offers of increasing sums of money, which the artists would then eat. The banknotes were returned to the successful bidder after having been passed through the artists' digestive system. As the project took place in the build up to the recent global recession, the piece took on the form of a sarcastic, irreverent response to the cavalier attitudes towards capital that brought

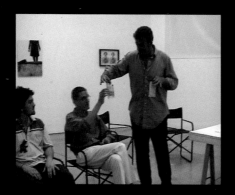

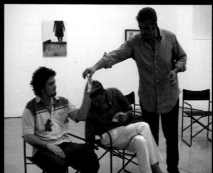

about the economic collapse. Further analysis of the piece posited that it articulated the change that we, as a society went through during this dark sociocultural period of European history: "Notions like irreversible transformation, determination of value, paradoxical exchange and communal living are threads that come both from the past and from a projection of the future. All these issues were and still are deeply connected to our bodies, and with the same bodies we investigate them, with a typical Mediterranean approach, intellectually, politically and gastronomically."[2]

① http://moneyandart.tumblr.com/post/41681058140/cesare-pietroiusti-with-paul-griffiths-eating ② http://www.3137.gr/en/IL-CUOCO ⊕ ⊕ *Eating Money—An Auction*, 2007. Courtesy the artists.

Raul
Ortega Ayala

Raul Ortega Ayala was born in Mexico in 1973. He received his MFA from the Glasgow School of Art and Hunter College, New York, and has exhibited internationally as an artist. His work, Ortega Ayala states, is:

The direct result of combining anthropological and aesthetic processes to produce something that offers anthropological insight through aesthetic experience.... For the past decade my work resulted from immersions into different milieu, which I experienced and researched for extended periods of time, through the ethnographic method of participant observation. I took employment or training in the field in question and I then used the 'materials' and the embodied knowledge (from each experience) to produce a series of works that I call 'souvenirs' because of their intrinsic link to an experience. These are paired with 'field-notes' to offer a response to and an insight into my experience of the subject researched. Most recently I have inverted my methodology and instead of immersing myself as a participant observer I've begun working from a 'distance' researching issues on social amnesia and the politics of memory through some of the methods that historians use.[1]

Tomatina/Tim, 2010, comprises an opposing, two-screen video installation, and is part of the series entitled *Food for thought*, which explores food beyond bodily sustenance. One film documents the Tomatina festival, held annually in the town of Buñol, Spain, in which thousands of revellers congregate to throw five tons of tomatoes at one another over the course of an hour, in a gesture of surreal, carnivalesque debauchery. The second depicts an American professional competitive eater, who consumes 40 hotdogs in ten minutes. Ortega Ayala reads the imagery of these events as "involuntary metaphors of our times", utilising the disparate and fundamentally opposed notions of ingestion and flagrant wastage to explore issues of decadence, abundance and excess.

1. http://www.stroom.nl/activiteiten/tentoonstelling.php?t_id=1013973.
2. *Tomatina / Tim*, 2010, 2-screen video installation, duration 14 minutes. Courtesy the artist.

Gayle Chong Kwan

Using everyday objects and food waste, London-based artist Gayle Chong Kwan creates intricate fantasy landscapes, fictional environments and visual narratives.

As a Fine Art graduate of Central Saint Martins and the Royal College of Art, who has also studied Politics and Modern History, and Communications at the Universities of Manchester and Sterling respectively, Chong Kwan creates work from an idiosyncratic and informed viewpoint. Based not only on her varied academic history, Chong Kwan's fantasy worlds draw inspiration from her childhood in Scotland and the island of Mauritius, home of her father, to explore both our perception of myth and real, modern landscapes. Memory, therefore, forms an integral aspect in creating Chong Kwan's work, but memories of the viewer are also evoked by the use of materials that play on each of the senses.

Clearly requiring significant practical skill and imagination, many of Chong Kwan's pieces, such as *Paris Remains,* have an ethereal — and to some extent even disturbing — quality to them. Using waste as a building material gives her landscapes the effect of ghostly dystopias, partly arising from the overwhelming amount of detail within them; crumbling buildings on degrading streets are adorned with minute windows and doorways, and a simplified Eiffel Tower sits in front of a cut-out 'Paris' skyline.

A different approach is shown in Chong Kwan's *Les Precieuses* series, a photographic collection in which she draws the viewer's attention finally to waste so often overlooked: food discarded on the street.

⬆ *Paris Remains,* 2009, '7.58' Courtesy the artist. ↗ *Les Precieuses,* 'XIV', 2009. Courtesy the artist. ↘ *Les Precieuses,* 'XXV', 2009. Courtesy the artist.

178

Essays

Anti-Pasta

Romy Golan

Here is a photo of Filippo Tommaso Marinetti eating a plate of spaghetti in 1930. What looks like an anodyne photograph was in fact a highly loaded image, for this was the man who, together with his younger colleague Fillia (the pseudonym of Luiggi Colombo), had just published the "Manifesto of Futurist Cookery", 1930, which dared declare anathema Italy's sacrosanct pasta. Marinetti saw the Italian table as weighted down by heavy traditional food. The English might be content with their dried cod, roast beef, and pudding, the Germans with their sauerkraut, smoked bacon, and sausages, but for the Italians pasta would no longer do. Marinetti wanted to reverse the best-known chapter of the history of Italian cuisine. In the seventeenth century, the city of Naples had initiated a gastronomic revolution whereby its inhabitants, until then known as *mangiabroccoli* and *mangiafoglie*, now became *mangiamaccheroni*. The pasta eater, holding the spaghetti in his hands above his mouth, became a stock figure, like the characters of Commedia dell'Arte, disseminated in prints all over Europe. Now the Futurists were calling for the abolition of what they deemed an absurd Italian gastronomic religion. Marshalling the opinions of doctors, professors, hygienists and impostors, Marinetti claimed that pasta induced lethargy, pessimism,

nostalgia and neutralism. In short, pasta stood behind everything the Futurists had been battling ever since the appearance of their initial manifesto in 1909.

They lamented that *pastasciutta*—dried pasta of the sort we all eat—was 40 per cent less nutritious than meat, fish and vegetables. Mixing scientific data with poetic flights of eloquence, Marinetti held that pasta ensnared Italians within the slow looms of Penelope and bound them to the sailing ships somnolently awaiting a gust of wind on a sleepy Mediterranean. Being anti-pasta meant being *antipassatista*, ie, against the past.

Predictably, upon its publication in the Turin daily *Gazetta del Popolo* on 28 December 1930, and its translation in the Parisian daily *Comoedia* a few months later, the manifesto provoked an uproar. Delighted to have finally managed to write a manifesto that, in line with Futurism's intent to transform every aspect of life, had finally hit on the one realm of the quotidian that affected every single Italian, Marinetti and Fillia gleefully devoted a whole section of their 1932 *Futurist Cookbook* to recording the blistering effects of the initial cooking manifesto. In typical Futurist fashion, the section containing the polemic preceded the section with the actual recipes. Marinetti and Fillia claimed, in equally characteristic Futurist inflationary style, that the pros and cons of pasta were endlessly debated in the Italian press in hundreds of articles by writers, politicians, chemists and famous cooks, not to mention innumerable cartoons. Meanwhile, foreign publications from London to Budapest, from Tunis to Tokyo, and all the way to Sydney had announced somewhat incredulously that Italy was about to abandon spaghetti. In the city of l'Aquila (a few hours from the Italian capital) women had taken the situation into their own hands by signing a collective letter of indignation, addressed to Marinetti, in favour of pasta. In Genoa, an association called PIPA (International Association Against Pasta) was formed. Thousands of miles away in San Francisco, a fight had erupted between two Italian restaurants situated on different floors of the same building. While the head cook of the Savoia, Italy's royal family, actually came out against pasta, the mayor of Naples professed that vermicelli with tomato sauce was the food of the angels. To which Marinetti responded that if that were the case, it simply served to confirm the boredom of life in paradise.

Ultimately, Marinetti believed, modern science would allow us to replace food with free, state-sponsored pills composed of albumins, synthetic fats, and vitamins that would lower prices for the consumer and lessen the toll of labour on the worker. Ultraviolet

lamps could be used to electrify and thus dynamise food staples. Eventually, totally mechanised production would relieve humankind of labour altogether, allowing man to be at leisure to pursue nobler activities. Dining could thus become a purely aesthetic enterprise. On this premise, Marinetti and Fillia's proposals for the new Italian cuisine constitute one of the most inspired chapters in the annals of Futurism. The cookbook gave a new infusion of *giovinezza*—a favourite Fascist word, meaning 'youth'—to the slightly tired antics of a movement now known as Secondo Futurismo. While the spectator could already expect, by the 1930s, to be abused by the Futurist text, the Futurist painting, the Futurist *polimaterico* (multimedia sculpture), and the Futurist performance, here the abuse went not to the head, but straight to the stomach.

The polemics in *The Futurist Cookbook* were followed by an elaborate account of some Futurist banquets. One of the more memorable of these *Aeropranzi futuristi* was a banquet for 300 people held on 18 December 1931 at the Hotel Negrino in Chiavari. Guests were delighted and terrified as they braced themselves to ingest dishes prepared by the famous cook Bulgheroni, who had come especially from Milan to this small Ligurian town to preside in the kitchen over the burial of *pastasciutta*. Although the Futurists had advocated the abolition of eloquence and politics around the table, the guests nevertheless first had to sit through a lecture by Marinetti on the state of world Futurism. Afterward, the meal began with a flan of calf's head seated on a bed of pineapple, nuts, and dates, stuffed—oh, surprise!—with anchovies. Then, to cleanse the palate, Bulgheroni served a *decollapalato* (a pun on *decollare*, meaning "to get off the ground"), a lyrical concoction of meat broth sprinkled with champagne and liquor and decorated with rose petals. The main dish was beef in *carlinga* (another aeronautic term, probably referring to a kind of Dutch oven)—meatballs, whose composition was best left uninvestigated, placed over aeroplanes made out of bread crumbs. After a few more dishes the dessert, named *eletricita atmosferiche candite*, arrived, consisting of colourful little cubes made of fake marble crowned with cotton candy that enclosed a sweetish paste containing ingredients only a long chemical analysis could disclose. Not everybody made it to the end of the dinner.

Most memorable among other Futurist recipes was the *carneplastico*: a synthetic sculptural interpretation of Futurist *aeropittura* referring to the much-beloved Italian landscape. In honour of the beacon of Italian industry, one could taste the *pollo Fiat*, a stuffed chicken placed on puffy pillows of whipped cream. On a more pornographic note, one could also have a *porco eccittato*, a cooked salami placed vertically on the plate with coffee sauce mixed with eau de cologne.

Whatever Marinetti might have thought about his capacities for perennial transgression, such conceits of dishes as 'divine surprises' had a long historical lineage. They went back to the most extraordinary passages in Petronius Arbitrius' *Satiricon*, thus reviving an aspect of *Romanita* that the Fascists, in their eagerness to revive Roman glories, would have been all too happy to endorse. Indeed, many of the ingredients were coded so that the exotic fruits that appear in so many Futurist dishes were meant to evoke Italy's hope for a firmer grip on North Africa in fulfilment of its imperial ambitions as master of the Mediterranean. There was, it turns out, some disagreement during the Fascist *ventennio* as to the ür-history of pasta. According to the story presently told in Rome's Museo Nazionale della Pasta Alimentare (the only such museum in the world, founded in the 1990s), traces of early pasta implements were found in the archeological remains of the Etruscan town of Cerveteri, near Rome, dating to the fourth century BCE. Pasta was also identified in low reliefs of the twelfth century. And yet the writer Paolo Buzzi, in an article printed in 1930 in the much-venerated journal *La Cucina Italiana*, pointed to the fact that no mention of pasta by the ancient Romans could be found in the history of Italian cooking by d'Apico, the Homer of cooking. This might sound strange, he added, if one thinks of the thousand stories one was told as a child about the catastrophic volcanic eruption of Pompeii, one of which told of plates, still filled with *maccheroni*, thrown into the lava.

As always with Futurism, Marinetti's *ottimismo della tavola* had its darker side in the realm of realpolitik. Not by chance, as he himself acknowledged in the manifesto, Marinetti launched his attack against pasta just when Italy, hit hard by the Depression, was struggling to achieve one of Mussolini's great dreams: autarchy, or the elimination of Italy's economic dependence on foreign markets. Pasta, quintessentially Italian as it was, depended on expensive imports of wheat. The regime thus launched a campaign in favour of homegrown rice as a better substitute. Rice, we are told, was more virile, more patriotic, and more suitable for fighters and heroes. Rice also had its part in the history of Italian cooking as the great rival of pasta; it came from the Po valley in the industrial North, while pasta, with its hypothetical birthplace in Etruria and its triumph in Naples, was identified with the centre, and even more with the agrarian and backward South. This was a

battle that could thus be waged on familiar Futurist geopolitical territory.

And so the Futurists offered *tuttoriso*: new dishes to replace the traditional Northern risotto. More sinister is the fact that among the doctors summoned by Marinetti was the eugenicist Nicola Pende, the man behind the new Instituto di Biotipologia in Rome. Marinetti's attacks against pasta coincided, significantly I think, with the first wave of Taylorisation of pasta production. On display in the Museo della Pasta in Rome are vintage photographs of women (almost never men) at work in front of vertical hydraulic presses, grinders, cutters, and blenders that look no less impressive, no less daunting, and no less alienating, than the assembly line at Fiat's famous Turin factory known as the *Lingotto*, a Futurist favourite back in the teens. By the 1930s, the institution of biotypes as substitutes for Taylorism to attain maximal efficiency in the working place and the provision of a master race had taken hold of the Fascist imagination. Thus the New Futurist Man, the man without pasta, the *homo ludens* who might eventually replace *homo edens*, the man whom one may be tempted to theorise as the postmodern "desiring machine" of Gilles Deleuze and Felix Guattari in *Anti-Oedipus*, was, then, first and foremost, the New Fascist Man.

Fine. But what is one to make of our Marinetti snapshot? The staple photograph we see reproduced shows Marinetti instructing a female cook on how to concoct one of his recipes, both of them standing in front of a 1913 *Muscular Dynamism* painted by Umberto Boccioni. So is our photograph here of Marinetti caught red-handed in the act of eating the infamous dish? A good Italian who just couldn't resist? And this taking place at Biffi, if one is to believe the caption, one of the best-known Milanese establishments (still in existence) and a favourite haunt of the Futurists? Or is it a clever manoeuvre by Marinetti intended to bamboozle the viewer, leave him or her guessing, spinning yet still more controversy? About to send off my text and still wavering between these two interpretations of this piece of photographic evidence, I stumbled on one little paragraph of *The Futurist Cookbook*. There, entry number seven in a short section on apocryphal anecdotes provided a possible answer: "Photographs of Marinetti in the act of eating pasta appeared in a few mass-circulation magazines: they were photographic montages carried out by experts hostile to Futurist cuisine, who were trying to discredit the campaign for a new way of eating."[1] There could, however, be another reading: the photo is real and Marinetti, whatever he might have claimed in his cookbook, was simply lying about the montage. There must have been moments when, even for Marinetti, the desires of the everyman vanquished those of the Futurist and the Fascist in him.

First printed in *Cabinet* No. 10, Spring 2003. Romy Golan is professor of contemporary European art and theory in twentieth-century European art at the CUNY Graduate Center. She is the author of *Modernity and Nostalgia: Art and Politics in France between the Wars* and coauthor of the catalogue for *The Circle of Montparnasse: Jewish Artists in Paris 1905–1945*, an exhibition at the Jewish Museum in New York.
(1) Marinetti, Filippo Tommaso, *The Futurist Cookbook*, Suzanne Brill trans, San Francisco: Bedford Arts, 1989, p 99.

Food Sex Art "Preface"

Paul & Melissa EIDIA

"LM: You don't consider Fluxus art?
GM: I... no. I think it's good inventive gags. That's what we're doing. And there's no reason why a gag, some people, if they want to call it art, fine, you know. Like I think of gags of Buster Keaton are really a high art form, you know, heh, heh, sight gags.... Because we've never intended (it) to be high art."[1]

"We have joined art to life. After the long isolation of artists, we have loudly summoned life and life has invaded art, it is time for art to invade life. The painting of our faces is the beginning of the invasion. That is why our hearts are beating so."
Mikhail Larionov and Ilya Zdanevich, "Why We Paint Ourselves: A Futurist Manifesto", 1913.[2]

"About nine years ago [1961], in Copenhagen, I bought some foodstuffs at random, stamped them "attention work of art" and resold them at shop prices through a gallery. If I could have foreseen the future I would have planned the operation on a longer-term basis. But only later did I fully realise how important EAT ART theme was to become for me."
Daniel Spoerri recalling the origins of EAT ART.[3]

Food art is art that doesn't seem to be art. It is art through non-art means. In this context we would like you to place *The Starving Artists' Cookbook* in a historical avant-garde dialectic, a continuum going back 80 years to the beginning of this century and the

origins of a conscious avant-garde. The inchoation of this avant-garde stemmed from artists' realisation of an art not bound to traditional definitions or stricture, an art that could encompass all aspects of life. These artists wished to be freed from the aestheticism of the objet d'art by advancing the ideas behind their art through direct interaction/participation of the art audience. This then became an art that challenged the status quo by alchemising everyday objects and events into an 'art' and at the same time 'non-art' status.

It is a current art world observation that 'avant-garde-ism' no longer exists. Post-Modernism has taken Modernist Formalism to the second hand store and dumped it there to sell to the highest bidders (it is said). In effect, Post-Modernism has taken all meaning and spirituality out of 'art' and transformed it into a commodity. We would suggest that it is not artists that have robbed 'art' of a new creative expression, but the art institutions (museums, schools) that exist through the codification, objectification and the aestheticism of art by relegating 'art', that is outside the formalist aesthetic 'master system', to a second class status.

There is and probably always will be an avant-garde which remains for the most part outside the accepted typologies set in place by art institutions. This art is not about aesthetics per se, but has everything to do with conceptual expression and thought, vis-à-vis the ways in which art can exist by extension in life. This is true avant-garde art.

In the search for examples of 'food art' by the early avant-garde, we ran across the work of Russian artist Mikhail Larionov and his "Rayonist Cooking Manifesto", 1912–1913, as well as his illusionistic dinners that included soup of wine, figures of animals, birds and plants made from bread.[4] It is perhaps appropriate that this work comes out of a period where the art revolution was concurrent with the political revolution in Russia. Radical art of pre-revolutionary Russia was evidence of a broad discontent with life as it was, society on the verge of a break down. This was soon to be evident in the rest of Europe with the approach of the First World War. The art international fore-shadowed these societal changes. It seemed to some artists that making, at such a time, respectable paintings and sculpture for the bourgeoisie was absurd.

Rayonism and Constructivism in Russia, Futurism in Italy, German Expressionism, Dada, Bauhaus, and, later, Duchamp's readymades in America were all art activities expressing contemporary aspects of life through art. In these movements the conception behind the art was sometimes more important than the object

itself. In fact, the object was often used as an instigation for an art-life response and of no intrinsic importance of itself. An example of this is the impact of Marcel Duchamp's *Fountain*, a urinal, entered in the 1917 Armory Show signed "R. MUTT", rejected and then misplaced. Today it is represented only by a photograph.

Food art in this context also ties into the late nineteenth-century 'myth' (which started earlier in the century) of the starving artist, represented most manifestly by the 'drop-out bohemian' lives of Van Gogh and Gaugin. This romantic idea of the artist who disavows his bourgeois life for the sake of art (whether it is true or not) becomes an image almost more powerful than the art they produced. The performance of their lives in the pursuit of art became recognised as a cultural signifier.

Paris at the turn of the century through the 1930s, in most minds, represents the pinnacle of an artistic community. This was art as life in its most naïve state. The artists were not literally 'starving', but were living cheaply and extolling food, sex and art by 'cafe hopping', performing and producing, all on the same level of intensity and radical intent in a conscience challenge to society. In this context, Gertrude Stain subtitled her 1914 book *Tender Buttons*; *Objects, Food, Rooms*. The objet d'art oftentimes being a pretext for life, and life becoming a work of art by placing itself in the mid of the larger society.

In 1930 Marinetti, a poet, painter and one of the originators of The Futurist movement, printed *The Futurist Cookbook* with the intent of fully involving the individual in the most intimate and necessary function of life and 'raising' it to the next level of art. To do so by making aware all the senses, not just the visceral and cerebral. On one hand, the book 'poses' itself as a scientific, sociological manual on the evils of conventional cooking and food consumption in Italy. It bans the use of pasta and heavy multi-course bourgeois meals and promotes rice, small bite-size dishes, and modern industrial cooking equipment. At the same time it contains poetic, sensual, outrageous and totally original recipes and anecdotes in collaboration with other artists and writers of the movement. Marinetti's contention is that, like art and literature, food must also conform to the Futurist philosophy and leave behind traditionalist forms. Perhaps, in trying to intensify and be involved in all aspects of modern existence, the Futurists are an example of the dangers of connecting art and life too adamantly. One of his dinners, "The Extremist Banquet", performed in a building expressly built for the dinner, consisted only of various smells,

poetry reading and food sculpture (not to be eaten). The dinner ends with the suggestion that the guests starve to death. The transcendent poetic aspects of the book are embodied in "The Dinner that Stopped a Suicide" where Marinetti relates the story of a dinner he made for a friend suicidal over his dead lover consisting of a cake in the form of the beloved one's body which his friend ate and overcame his grief.

As an artist representative of the post-Second World War Art/Life movements in Milan circa 1951, Piero Manzoni was aligned with a group called The Nucleurists and in 1957 developed a series of works called 'anchroms' (without colour) which were various objects covered with white plaster of kaolin (at about the same time Yves Klein was beginning his 'Monochrome' painting). *Anchrome, 1961–62* was 12 loaves of bread covered in plaster. In *To devour art*, 1961, Manzoni affixed his thumb-print to hard boiled eggs and invited audiences to eat them.

"Art is now a commodity like soap or securities....
The great artists of tomorrow will go underground."
Marcel Duchamp, 1961.[5]

Along with other radical social movements of the 1960, Fluxus East and West (Europe and America) evolved both as a collective and individual Art/Life dialectic. Developing about the same time as Pop art and consisting of the multi-media art froms of music, film, performance, dance, publications, ready mades, multiples and installations. The movement and its participants for the most part stayed out of the commercial art market and remained "underground". Although Fluxus influenced more established art movements, Pop, Minimalism, Conceptualism, to this day it remains a footnote in American art history. In many ways, it represents a culmination of all avant-garde art movements that preceded; and, in a conscious way, Fluxus is the standard bearer of what remains of the avant-garde today. More successful in Europe (in terms of recognition), it used the various conditions of food, sex, art and the rituals surrounding modern life as its subject matter. A playful, game-oriented joking quality often underlies a more biting commentary about our society. The numerous food art pieces testify to this—by way of example, George Maciunas' *Laxative Cookies* an unrealised idea-performance by the main founder of the movement.

Laxative Cookies: "Feb, 17, 1970: Fux Mass by George Maciunas... Communion: priest

with chasuble front a Venus de Milo offers to congregation cookies prepared with laxative and blue urine pills." [6]

This piece could be complemented by Fluxus East with Daniel Spoerri's EAT ART show, 1961, and *An Anecdoted Topography of Chance*, 1962, a catalogue of the objects in his Paris apartment. By way of much of this work being divorced from actual art objects and being presented in publications such as the *Fluxus Newspaper* or multiples, thus allowing the artist's economic freedom from the consumer culture and freedom to criticise it through a non-elitist art form.(As of this writing, it should be noted that Vytautus Landsbergis, the current president of Lithuania, was Maciunas' childhood friend and a Fluxus member. He is now holding out against a two month siege by the Russian military while staying in a government building.)

The Starving Artists' Cookbook is an attempt to present an instigation of art into life with sometimes mundane and sometimes outrageous means as represented by the thoughts, ideas, recipes and art collected in this book.

Ides of March, 1991

(1) From a video tape interview with George Maciunas by Larry Miller in 1978.
(2) Bowlt, John, "Russian Art of the Avant Garde", Thames and Hudson, Inc: New York, New York, 1988, p 81.
(3) English summary from an issue on Daniel Spoerri, "Du", Zurich, David Simon, trans, January 1989.
(4) Sergei Bugaev (Africa) and Andrei Khlobystov, "Flash Art", March/April 1990, p 124 (in an interview).
(5) *The New York Times*, 26 March 1961; Canaday, John, "Whither Art?" on remarks made at the Philadelphia Museum College of Art on the subject "Where do we go from here?".
(6) Maciunas, George, "Fluxus Newspaper No 9", 1970 (in John Hendricks, ed, "Fluxus Codex", 1988, p 143).

The Culinary Triangle

Claude Lévi-Strauss

Linguistics has familiarised us with concepts like 'minimum vocalism' and 'minimum consonantism' which refer to systems of oppositions between phonemes of so elementary a nature that every known or unknown language supposes them; they are in

fact also the first oppositions to appear in the child's language, and the last to disappear in the speech of people affected by certain forms of aphasia.

The two concepts are moreover not really distinct, since, according to linguists, for every language the fundamental opposition is that between consonant and vowel. The subsequent distinctions among vowels and among consonants result from the application to these derived areas of such contrasts as compact and diffuse, open and closed, acute and grave.

Hence, in all the languages of the world, complex systems of oppositions among phonemes do nothing but elaborate in multiple directions a simpler system common to them all: the contrast between consonant and vowel which, by the workings of a double opposition between compact and diffuse, acute and grave, produces on the one hand what has been called the "vowel triangle":

$$a$$
$$u \qquad i$$

and on the other hand the "consonant triangle":

$$k$$
$$p \qquad t$$

It would seem that the methodological principle which inspires such distinctions is transposable to other domains, notably that of cooking which, it has never been sufficiently emphasised, is with language a truly universal form of human activity: if there is no society without a language, not is there any which does not cook in if some manner at least some of its food.

We will start from the hypothesis that this activity supposes a system which is located — according to very difficult modalities in function of the particular cultures one wants to consider — within a triangular semantic field whose three points correspond respectively to the categories of the raw, the cooked and the rotted. It is clear that in respect to cooking the raw constitutes the unmarked pole, while the other two poles are strongly marked, but in different directions: indeed, the cooked is a cultural transformation of the raw, whereas the rotted is a natural transformation. Underlying our original triangle, there is hence a double opposition between elaborated/unelaborated on the one hand, and culture/nature on the other.

No doubt these notions constitute empty forms: they teach us nothing about the cooking of any specific society, since only observation can tell us what each one means by 'raw', 'cooked' and 'rotted', and we can

suppose that it will not be the same for all. Italian cuisine has recently taught us to eat *crudités* rawer than any in traditional French cooking, thereby determining an enlargement of the category of the raw. And we know from some incidents that followed the Allied landings in 1944 that American soldiers conceived the category of the rotted in more extended fashion than we, since the odour given off by Norman cheese dairies seemed to them the smell of corpses, and occasionally prompted them to destroy the dairies.

Consequently, the culinary triangle delimits a semantic field, but from the outside. This is moreover true of the linguistic triangles as well, since there are no phonemes a, i, u (or k, p, t) in general, and these ideal positions must be occupied, in each language, by the particular phonemes whose distinctive natures are closest to those for which we first gave a symbolic representation: thus we have a sort of concrete triangle inscribed within the abstract triangle. In any cuisine, nothing is simply cooked, but must be cooked in one fashion or another. Nor is there any condition of pure rawness: only certain foods can really be eaten raw, and then only if they have been selected, washed, pared or cut, or even seasoned. Rotting, too, is only allowed to take place in certain specific ways, either spontaneous or controlled.

Let us now consider, for those cuisines whose categories are relatively well-known, the different modes of cooking. There are certainly two principal modes, attested in innumerable societies by myths and rites which emphasise their contrast: the roasted and the boiled. In what does their difference consist? Roasted food is directly exposed to the fire; with the fire it realises an unmediated conjunction, whereas boiled food is doubly mediated, by the water in which it is immersed, and by the receptacle that holds both water and food.

On two grounds, then, one can say that the roasted is on the side of nature, the boiled on the side of culture: literally, because boiling requires the use of a receptacle, a cultural object; symbolically, in as much as culture is a mediation of the relations between man and the world, and boiling demands a mediation (by water) of the relation between food and fire which is absent in roasting.

The natives of New Caledonia feel this contrast with particular vividness: "Formerly", relates MJ Barrau, "they only grilled and roasted, they only 'burned' as the natives now say.... The use of a pot and the consumption of boiled tubers are looked upon with pride... as a proof of... civilization."

A text of Aristotle, cited by Salomon Reinach (*Cultes, Mythes, Religions*, V, p 63), indicates that the Greeks also thought that "in ancient times, men roasted everything".

Behind the opposition between roasted and boiled, then, we do in fact find, as we postulated at the outset, the opposition between nature and culture. It remains to discover the other fundamental opposition which we put forth: that between elaborated and unelaborated.

In this respect, observation establishes a double affinity: the roasted with the raw, that is to say the unelaborated, and the boiled with the rotted, which is one of the two modes of the elaborated. The affinity of the roasted with the raw comes from the fact that it is never uniformly cooked, whether this be on all sides, or on the outside and the inside. A myth of the Wyandot Indians well evokes what might be called the paradox of the roasted: the Creator struck fire, and ordered the first man to skewer a piece of meat on a stick and roast it. But man was so ignorant that he left the meat on the fire until it was black on one side, and still raw on the other.... Similarly, the Poconachi of Mexico interpret the roasted as a compromise between the raw and the burned. After the universal fire, they relate, that which had not been burned became white, that which had been burned turned black, and what had only been singed turned red. This explanation accounts for the various colours of corn and beans. In British Guiana, the Waiwai sorcerer must respect two taboos, one directed at roast meat, the other red paint, and this again puts the roasted on the side of blood and the raw.

If boiling is superior to roasting, notes Aristotle, it is because it takes away the rawness of meat, "roast meats being rawer and drier than boiled meats" (quoted by Reinach, *Cultes, Mythes, Religions*).

As for the boiled, its affinity with the rotted is attested in numerous European languages by such locutions as *pot pourri*, *olla podrida*, denoting different sorts of meat seasoned and cooked together with vegetables; and in German, *zu Brei zerkochetes Fleisch*, "meat rotted from cooking". American Indian languages emphasise the same affinity, and it is significant that this should be so especially in those tribes that show a strong taste for gamey meat, to the point of preferring, for example, the flesh of a dead animal whose carcass has been washed down by the stream to that of a freshly-killed buffalo. In the Dakota language, the same stem connotes putrefaction and the fact of boiling pieces of meat together with some additive.

These distinctions are far from exhausting the richness and complexity of the contrast between roasted and boiled. The boiled is cooked within a receptacle, while the roasted is cooked from without: the former thus evokes the concave, the latter the convex. Also the boiled can most often be ascribed to what might be called an "endo-cuisine," prepared for domestic use, destined to a small closed group, while the roasted belongs to "exo-cuisine," that which one offers to guests. Formerly in France, boiled chicken was for the family meal, while roasted meat was for the banquet (and marked its culminating point, served as it was after the boiled meats and vegetables of the first course, and accompanied by 'extraordinary fruits' such as melons, oranges, olives and capers).

The same opposition is found, differently formulated, in exotic societies. The extremely primitive Guayaki of Paraguay roast all their game, except when they prepare the meat destined for the rites which determine the name of a new child: this meat must be boiled. The Caingang of Brazil prohibit boiled meat for the widow and widower, and also for anyone who has murdered an enemy. In all these cases, prescription of the boiled accompanies a tightening, prescription of the roasted a loosening of familial or social ties.

Following this line of argument, one could infer that cannibalism (which by definition is an endo-cuisine in respect to the human race) ordinarily employs boiling rather than roasting, and that the cases where bodies are roasted—cases vouched for by ethnographic literature—must be more frequent in exo-cannibalism (eating the body of an enemy) than in endo-cannibalism (eating a relative). It would be interesting to carry out statistical research on this point.

Sometimes, too, as is often the case in America, and doubtless elsewhere, the roasted and the boiled will have respective affinities with life in the bush (outside the village community) and sedentary life (inside the village). From this comes a subsidiary association of the roasted with men, the boiled with women. This is notably the case with the Trumai, the Yagua and the Jivaro of South America, and with the Ingalik of Alaska. Or else the relation is reversed: the Assiniboin, on the northern plains of North America, reserve the preparation of boiled food for men engaged in a war expedition, while the women in the villages never use receptacles, and only roast their meat. There are some indications that in certain Eastern European countries one can find the same inversion of affinities between roasted and boiled and feminine and masculine.

The existence of these inverted systems naturally poses a problem, and leads one to think that the axes of opposition are still more numerous than one suspected, and that the peoples where these inversions exist refer to axes different from those we at first singled out. For example, boiling conserves entirely the meat and its juices, whereas roasting is accompanied by destruction and loss. One connotes economy, the other prodigality; the former is plebeian, the latter aristocratic. This aspect takes on primary importance in societies which prescribe differences of status among individuals or groups. In the ancient Maori, says Prytz-Johansen, a noble could himself roast his food, but he avoided all contact with the steaming oven, which was left to the slaves and women of low birth. Thus, when pots and pans were introduced by the whites, they seemed infected utensils; a striking inversion of the attitude which we remarked in the New Caledonians.

These differences in appraisal of the boiled and the roasted, dependent on the democratic or aristocratic perspective of the group, can also be found in the Western tradition. The democratic Encyclopaedia of Diderot and d'Alembert goes in for a veritable apology of the boiled: "Boiled meat is one of the most succulent and nourishing foods known to man…. One could say that boiled meat is to other dishes as bread is to other kinds of nourishment" (Article "Bouilli"). A half-century later, the dandy Brillat-Savarin will take precisely the opposite view:

> "We professors never eat boiled meat out of
> respect for principle, and because we have
> pronounced ex cathedra this incontestable
> truth: boiled meat is flesh without its juice….
> This truth is beginning to become accepted,
> and boiled meat has disappeared in truly
> elegant dinners; it has been replaced by a
> roast filet, a turbot, or a matelote."
> (Physiologie du goût, VI, J2).

Therefore if the Czechs see in boiled meat a man's nourishment, it is perhaps because their traditional society was of a much more democratic character than that of their Slavonic and Polish neighbours. One could interpret in the same manner distinctions made—respectively by the Greeks, and the Romans and the Hebrews—on the basis of attitudes toward roasted and boiled, distinctions which have been noted by M Piganiol in a recent article ("Le rôti et le bouilli," A Pedro Bosch-Gimpera, Mexico City, 1963).

Other societies make use of the same opposition in a completely different direction. Because boiling takes place without loss of substance, and within a complete enclosure, it is eminently apt to symbolise cosmic totality. In Guiana as well as in the Great Lakes region, it is thought that if the pot where game is boiling were to overflow even a little bit, all the animals of the species being cooked would migrate, and the hunter would catch nothing more. The boiled is life, the roasted death. Does not world folklore offer innumerable examples of the cauldron of immortality? But there has never been a spit of immortality. A Cree Indian rite admirably expresses this character of cosmic totality ascribed to boiled food. According to them, the first man was commanded by the Creator to boil the first berries gathered each season. The cup containing the berries was first presented to the sun, that it might fulfil its office and ripen the berries; then the cup was lifted to the thunder, whence rain is expected; finally the cup was lowered toward the earth, in prayer that it bring forth its fruits.

Hence we rejoin the symbolism of the most distant Indo-European past, as it has been reconstructed by Georges Dumézil: "To Mitra belongs that which breaks of itself, that which is cooked in steam, that which is well sacrificed, milk… and to Varuna that which is cut with the axe, that which is snatched from the fire, that which is ill-sacrificed, the intoxicating soma" (Les dieux des Germains, p 60). It is not a little surprising—but highly significant—to find intact in genial mid-nineteenth-century philosophers of cuisine a consciousness of the same contrast between knowledge and inspiration, serenity and violence, measure and lack of measure, still symbolised by the opposition of the boiled and the roasted: "One becomes a cook but one is born a roaster" (Brillat-Savarin); "Roasting is at the same time nothing, and an immensity" (Marquis de Cussy).

Within the basic culinary triangle formed by the categories of raw, cooked and rotted, we have, then, inscribed two terms which are situated: one, the roasted, in the vicinity of the raw; the other, the boiled, near the rotted. We are lacking a third term, illustrating the concrete form of cooking showing the greatest affinity to the abstract category of the cooked. This form seems to us to be smoking, which like roasting implies an unmediated operation (without receptacle and without water) but differs from roasting in that it is, like boiling, a slow form of cooking, both uniform and penetrating in depth.

Let us try to determine the place of this new term in our system of opposition. In the technique of smoking,

as in that of roasting, nothing is interposed between meat and fire except air. But the difference between the two techniques comes from the fact that in one the layer of air is reduced to a minimum, whereas in the other it is brought to a maximum. To smoke game, the American Indians (in whose culinary system smoking occupies a particularly important place) construct a wooden frame (a buccan) about five feet high, on top of which they place the meat, while underneath they light a very small fire which is kept burning for 48 hours or more. Hence for one constant—the presence of a layer of air—we note two differentials which are expressed by the opposition close/distant and rapid/slow. A third differential is created by the absence of a utensil in the case of roasting (any stick doing the work of a spit), since the buccan is a constructed framework, that is, a cultural object.

In this last respect, smoking is related to boiling, which also requires a cultural means, the receptacle. But between these two utensils a remarkable difference appears, or more accurately, is instituted by the culture precisely in order, it seems, to create the opposition, which without such a difference might have remained too ill-defined to take on meaning. Pots and pans are carefully cared for and preserved utensils, which one cleans and puts away after use in order to make them serve their purpose as many times as possible; but the buccan *must be destroyed immediately after use*, otherwise the animal will avenge itself, and come in turn to smoke the huntsman. Such, at least, is the belief of those same natives of Guiana whose other symmetrical belief we have already noted: that a poorly conducted boiling, during which the cauldron overflowed, would bring the inverse punishment, flight of the quarry, which the huntsman would no longer succeed in overtaking. On the other hand, as we have already indicated, it is clear that the boiled is opposed both to the smoked and the roasted in respect to the presence or absence of water.

But let us come back for a moment to the opposition between a perishable and a durable utensil which we found in Guiana in connection with smoking and boiling. It will allow us to resolve an apparent difficulty in our system, one which doubtless has not escaped the reader. At the start we characterised one of the oppositions between the roasted and the boiled as reflecting that between nature and culture.

Later, however, we proposed an affinity between the boiled and the rotted, the latter defined as the elaboration of the raw by natural means. Is it not contradictory that a cultural method should lead to a natural result? To put it in other terms, what, philosophically, will be the value of the invention of pottery (and hence of culture) if the native's system associates boiling and putrefaction, which is the condition that raw food cannot help but reach spontaneously in the state of nature?

The same type of paradox is implied by the problematics of smoking as formulated by the natives of Guiana. On the one hand, smoking, of all the modes of cooking, comes closest to the abstract category of the cooked; and—since the opposition between raw and cooked is homologous to that between nature and culture—it represents the most "cultural" form of cooking (and also that most esteemed among the natives). And yet, on the other hand, its cultural means, the buccan, is to be immediately destroyed. There is a striking parallel to boiling, a method whose cultural means (the receptacles) are preserved, but which is itself assimilated to a sort of process of auto-annihilation, since its definitive result is at least verbally equivalent to that putrefaction which cooking should prevent or retard.

What is the profound sense of this parallelism? In so-called primitive societies, cooking by water and smoking have this in common: one as to its means, the other as to its results, is marked by duration. Cooking by water operates by means of receptacles made of pottery (or of wood with peoples who do not know about pottery, but boil water by immersing hot stones in it): in all cases these receptacles are cared for and repaired, sometimes passed on from generation to generation, and they number among the most durable cultural objects. As for smoking, it gives food that resists spoiling incomparably longer than that cooked by any other method. Everything transpires as if the lasting possession of a cultural acquisition entailed, sometimes in the ritual realm, sometimes in the mythic, a concession made in return to nature: when the result is durable, the means must be precarious, and vice-versa.

This ambiguity, which marks similarly, but in different directions, both the smoked and the boiled, is that same ambiguity which we already know to be inherent to the roasted. Burned on one side and raw on the other, or grilled outside, raw within, the roasted incarnates the ambiguity of the raw and the cooked, of nature and culture, which the smoked and the boiled must illustrate in their turn for the structure to be coherent. But what forces them into this pattern is not purely a reason of form: hence the system demonstrates that the art of cooking is not located entirely on the side of culture. Adapting itself to the exigencies of the body, and determined in its modes by the way man's insertion in nature operates in different parts of the world, placed then between

nature and culture, cooking rather represents their necessary articulation. It partakes of both domains, and projects this duality on each of its manifestations.

But it cannot always do so in the same manner. The ambiguity of the roasted is intrinsic, that of the smoked and the boiled extrinsic, since it does not derive from things themselves, but from the way one speaks about them or behaves toward them. For here again a distinction becomes necessary: the quality of naturalness which language confers upon boiled food is purely metaphorical: the 'boiled' is not the 'spoiled'; it simply resembles it. Inversely, the transfiguration of the smoked into a natural entity does not result from the nonexistence of the buccan, the cultural instrument, but from its voluntary destruction. This transfiguration is thus on the order of metonymy, since it consists in acting as if the effect were really the cause. Consequently, even when the structure is added to or transformed to overcome a disequilibrium, it is only at the price of a new disequilibrium which manifests itself in another domain. To this ineluctable dissymmetry the structure owes its ability to engender myth, which is nothing other than an effort to correct or hide its inherent dissymmetry.

To conclude, let us return to our culinary triangle. Within it we traced another triangle representing recipes, at least the most elementary ones: roasting, boiling and smoking. The smoked and the boiled are opposed as to the nature of the intermediate element between fire and food, which is either air or water. The smoked and the roasted are opposed by the smaller or larger place given to the element air; and the roasted and the boiled by the presence or absence of water. The boundary between nature and culture, which one can imagine as parallel to either the axis of air or the axis of water, puts the roasted and the smoked on the side of nature, the boiled on the side of culture as to means; or, as to results, the smoked on the side of culture, the roasted and the boiled on the side of nature:

<p align="center">RAW

roasted

(-) (-)

Air Water

(+) (+)

smoked boiled

COOKED ROTTED</p>

The operational value of our diagram would be very restricted did it not lend in itself to all the transformations necessary to admit other categories

of cooking. In a culinary system where the category of the roasted is divided into roasted and grilled, it is the latter term (connoting the lesser distance of meat from fire) which will be situated at the apex of the recipe triangle, the roasted then being placed, still on the air-axis, halfway between the grilled and the smoked. We may proceed in similar fashion if the culinary system in question makes a distinction between cooking with water and cooking with steam; the latter, where the water is at a distance from the food, will be located halfway between the boiled and the smoked.

A more complex transformation will be necessary to introduce the category of the fried. A tetrahedron will replace the recipe triangle, making it possible to raise a third axis, that of oil, in addition to those of air and water. The grilled will remain at the apex, but in the middle of the edge joining smoked and fried one can place roasted-in-the-oven (with the addition of fat), which is opposed to roasted-on-the-spit (without this addition). Similarly, on the edge running from fried to boiled will be braising (in a base of water and fat), opposed to steaming (without fat, and at a distance from the water). The plan can be still further developed, if necessary, by addition of the opposition between animal and vegetable foodstuffs (if they entail differentiating methods of cooking), and by the distinction of vegetable foods into cereals and legumes, since unlike the former (which one can simply grill), the latter cannot be cooked without water or fat, or both (unless one were to let the cereals ferment, which requires water but excluded fire during the process of transformation). Finally, seasonings will take their place in the system according to the combinations permitted or excluded with a given type of food.

After elaborating our diagram so as to integrate all the characteristics of a given culinary system (and no doubt there are other factors of a diachronic rather than a synchronic nature; those concerning the order, the presentation and the gestures of the meal), it will be necessary to seek the most economical manner of orienting it as a grille, so that it can be superposed on other contrasts of a sociological, economic, aesthetic or religious nature: men and women, family and society, village and bush, economy and prodigality, nobility and commonality, sacred and profane, etc. Thus we can hope to discover for each specific case how the cooking of a society is a language in which it unconsciously translates its structure — or else resigns itself, still unconsciously, to revealing its contradictions.

Translated from the French by Peter Brook

Acknowledgements

First and foremost, thanks must go to Sylvia Ugga for her elegant and striking design work, and to Marianne Templeton for her assistance with conceptualising and outlining the book's content. In addition, many thanks to Phoebe Adler, Hannah Newell, Conni Rosewarne, Garrett Schaffel, Milena Vassova and Kitty Walker for their invaluable editorial and research assistance on the book, to Florent Tanet for so generously sharing his work to illustrate the book's cover and interior, and to the many individuals who contributed to the project with patience and enthusiasm.

Cover photography by Florent Tanet

Edited by Thomas Howells and Leanne Hayman
Designed by Sylvia Ugga at Black Dog Publishing

Black Dog Publishing Limited
10a Acton Street
London WC1X 9NG
United Kingdom

TEL +44 (0)20 7713 5097
FAX +44 (0)20 7713 8682
info@blackdogonline.com
www.blackdogonline.com

British Library Cataloguing-in-Publication Data. A CIP
record for this book is available from the British Library
ISBN 9781908966407

Black Dog Publishing Limited, London, UK, is an
environmentally responsible company. *Experimental
Eating* is printed on sustainably sourced paper

art design fashion
history photography
theory and things

www.blackdogonline.com